# EARTH AS ART

Library of Congress Cataloging-in-Publication Data

Friedl, Lawrence.

Earth as art / Lawrence Friedl, Karen Yuen...[et.al.].

   p. cm.

   Summary: "[Images from Earth-observing environmental
satellites in orbit around the planet. This book shows patterns,
shapes, colors, and textures of the land, oceans, ice, and
atmosphere]"--Provided by publisher.

   1.  Earth--Pictorial works.  I. Yuen, Karen. II. Title.

   QB637.F75 2012

   550.22'2--dc23

                                    2012031026

ISBN 978-0-16-091365-5

For sale by the  Superintendent of Documents,  U.S. Government Printing Office
Internet: bookstore.gpo.gov   Phone: toll free (866) 512-1800;   DC area (202) 512-1800
Fax: (202) 512-2104 Mail: Stop IDCC, Washington, DC 20402-0001

ISBN 978-0-16-091365-5

EARTH AS ART

ii

We must look to the heavens . . .
for the measure of the earth.

Jean-Félix Picard

# Contents

viii    Foreword

2    Akpatok Island, Canada

4    Aleutian Clouds, Bering Sea

6    Algerian Desert, Algeria

8    Alluvial Fan, China

10    Anti-Atlas Mountains, Morocco

12    Anyuyskiy Volcano, Russia

14    Belcher Islands, Canada

16    Bogda Mountains, China

18    Bombetoka Bay, Madagascar

20    Brandberg Massif, Namibia

22    Byrd Glacier, Antarctica

24    Cape Farewell, New Zealand

26    Carbonate Sand Dunes, Atlantic Ocean

28    Carnegie Lake, Australia

30    Dardzha Peninsula, Turkmenistan

32    Dasht-e Kavir, Iran

34    Desolation Canyon, United States

36    East African Rift, Kenya

38    Edrengiyn Nuruu, Mongolia

40    Erg Chech, Algeria

42    Erg Iguidi, Algeria and Mauritania

44    Erongo Massif, Namibia

46  Garden City, United States

48  Grand Bahama Bank, Atlantic Ocean

50  Gravity Waves, Above the Indian Ocean

52  Great Salt Desert, Iran

54  Himalayas, Central Asia

56  Ice Waves, Greenland

58  Isla Espíritu Santo and Isla Partida, Mexico

60  Jebel Uweinat, Egypt

62  Kalahari Desert, Southern Africa

64  Kamchatka Peninsula, Russia

66  Kilimanjaro, Kenya and Tanzania

68  Kuril Islands, Sea of Okhotsk

70  La Rioja, Argentina

72  Lake Disappointment, Australia

74  Lake Eyre, Australia

76  Lena River Delta, Russia

78  MacDonnell Ranges, Australia

80  Mayn River, Russia

82  Meandering Mississippi, United States

84  Mississippi River Delta, United States

86  Mount Elgon, Kenya and Uganda

88  Musandam Peninsula, Oman

90  Namib Desert, Namibia

92  Nazca Lines, Peru

94  Niger River, Mali

96  Okavango Delta, Botswana

98  Painted Desert, United States

100  Paraná River Delta, Argentina

102  Phytoplankton Bloom, Baltic Sea

104  Pinacate Volcano Field, Mexico

106  Ribbon Lakes, Russia

108  Richat Structure, Mauritania

110  Rocky Mountain Trench, Canada

112  Rub' al Khali, Arabian Peninsula

114  Sand Hills, United States

116  Shoemaker Crater, Australia

118  Sierra Madre Oriental, Mexico

120  South Georgia Island, South Atlantic Ocean

122  Southern Sahara Desert, Africa

124  Susitna Glacier, United States

126  Syrian Desert, West Asia

128  Tassili n'Ajjer, Algeria

130  Terkezi Oasis, Chad

132  Three Massifs, Sahara Desert

134  Tibetan Plateau, Central Asia

136  Tikehau Atoll, French Polynesia

138  Triple Junction, East Africa

140  Ugab River, Namibia

142  Vatnajökull Glacier Ice Cap, Iceland

144  Volcanoes, Chile and Argentina

146  Von Kármán Vortices, Southern Pacific Ocean

148  Wadi Branches, Jordan

150  Zagros Mountains, Iran

152  About the Book

154  Appendix

158  Acknowledgments

## Foreword

In 1960, the United States put its first Earth-observing environmental satellite into orbit around the planet. Over the decades, these satellites have provided invaluable information, and the vantage point of space has provided new perspectives on Earth. This book celebrates Earth's aesthetic beauty in the patterns, shapes, colors, and textures of the land, oceans, ice, and atmosphere. Earth-observing environmental satellites can measure outside the visible range of light, so these images show more than what is visible to the naked eye. The beauty of Earth is clear, and the artistry ranges from the surreal to the sublime. Truly, by escaping Earth's gravity we discovered its attraction.

Earth as art—enjoy the gallery.

Lawrence Friedl
NASA Earth Science

# Akpatok Island
# Canada

Akpatok Island rises sharply out of the frigid water of Ungava Bay in northern Quebec, Canada. Composed primarily of limestone, the island is a flat, treeless plateau 23 kilometers wide, 45 kilometers long, and about 150 to 250 meters high. This 2001 Landsat 7 image shows Akpatok Island completely covered in snow and ice. Small, dark patches of open water appear between pieces of pale blue-green sea ice, and a few scattered clouds are shown in red. The surrounding sea and ice are home to polar bears, walruses, and whales. A traditional hunting ground for native Inuit people, Akpatok is almost inaccessible except by air. The island is an important sanctuary for seabirds that make their nests in the steep cliffs that circle the island.

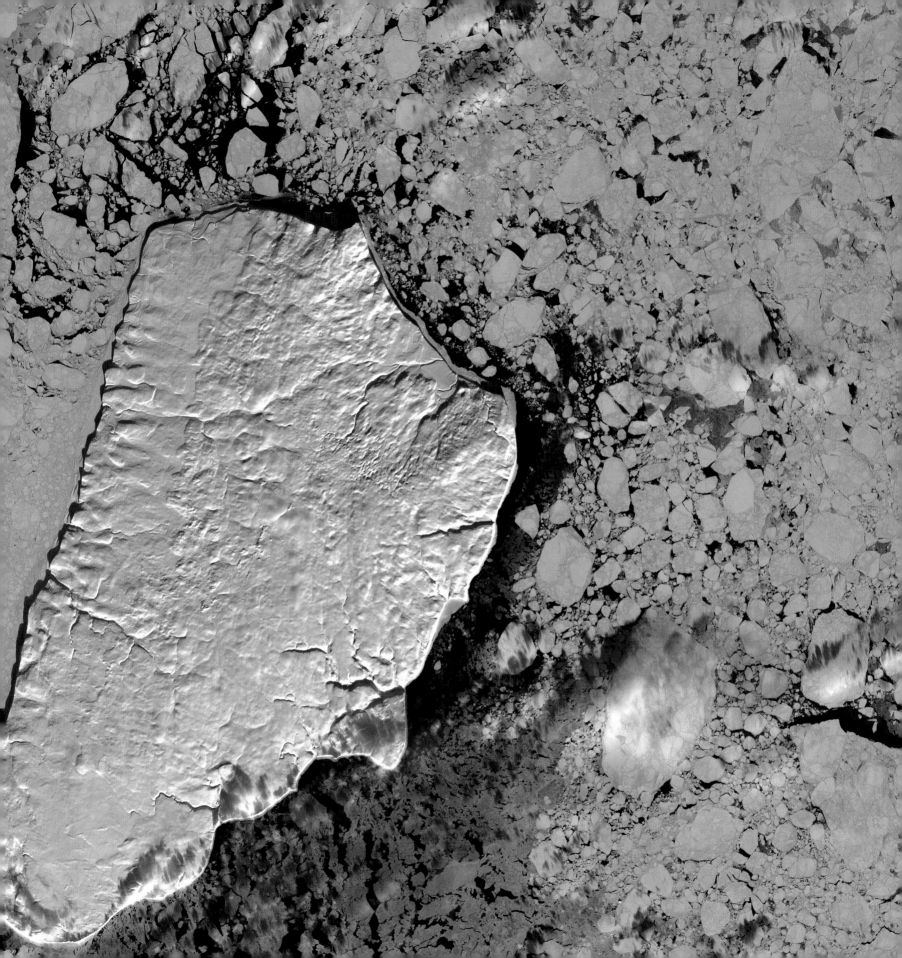

## Aleutian Clouds
## Bering Sea

Clouds hover over the waters off the western Aleutian Islands, where fog, heavy rains, and high winds are common. While the clouds in this 2000 Landsat 7 image are structured differently, all the clouds shown are low, marine stratocumulus clouds, which often produce drizzle. The color variations are probably due to differences in the temperature and in the size of the water droplets that make up the clouds. The Aleutian Islands are part of the Pacific Ring of Fire. The archipelago curves out 1,800 kilometers from southwestern Alaska towards Russia's Kamchatka Peninsula.

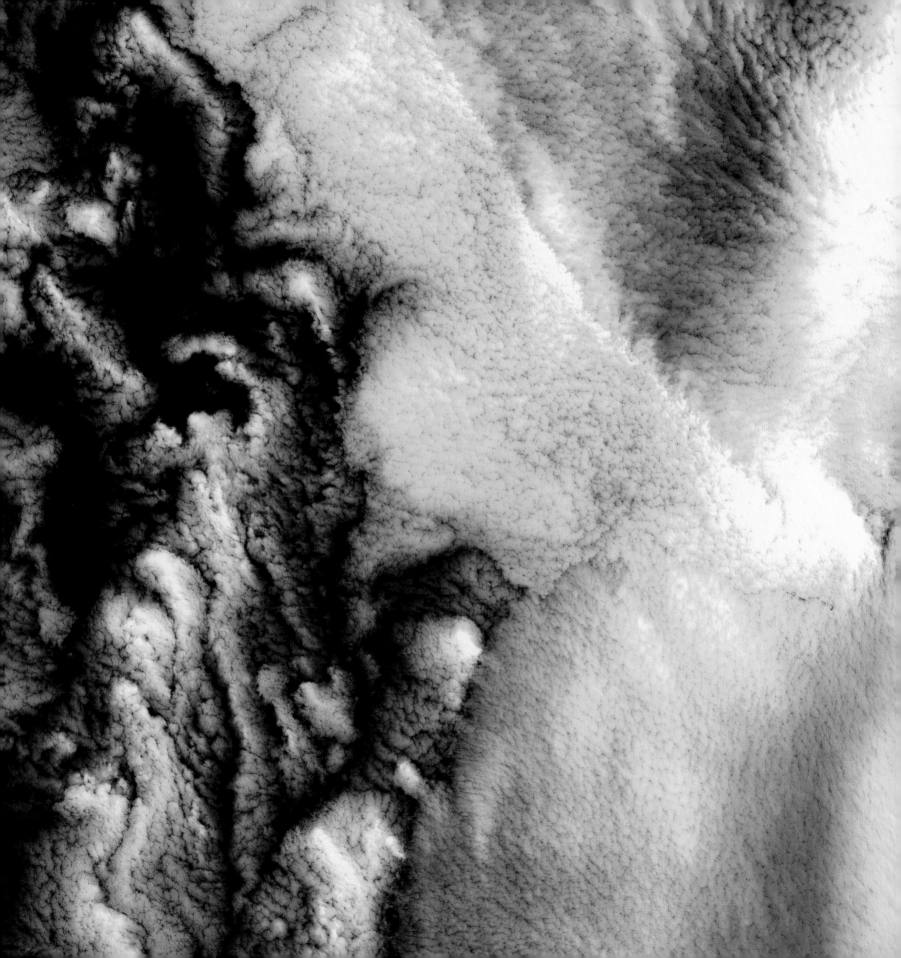

# Algerian Desert
## Algeria

Lying amid the Great Eastern Erg, the Great Western Erg, and the Atlas Mountains in Northern Africa, the Sahara Desert in central Algeria is dotted by fragmented mountains (in brown, lower right) where barren, windswept ridges overlook arid plains. In this Landsat 5 image from 2009, a system of dry streambeds crisscrosses the rocky landscape awaiting the rare, intense rains that often cause flash floods.

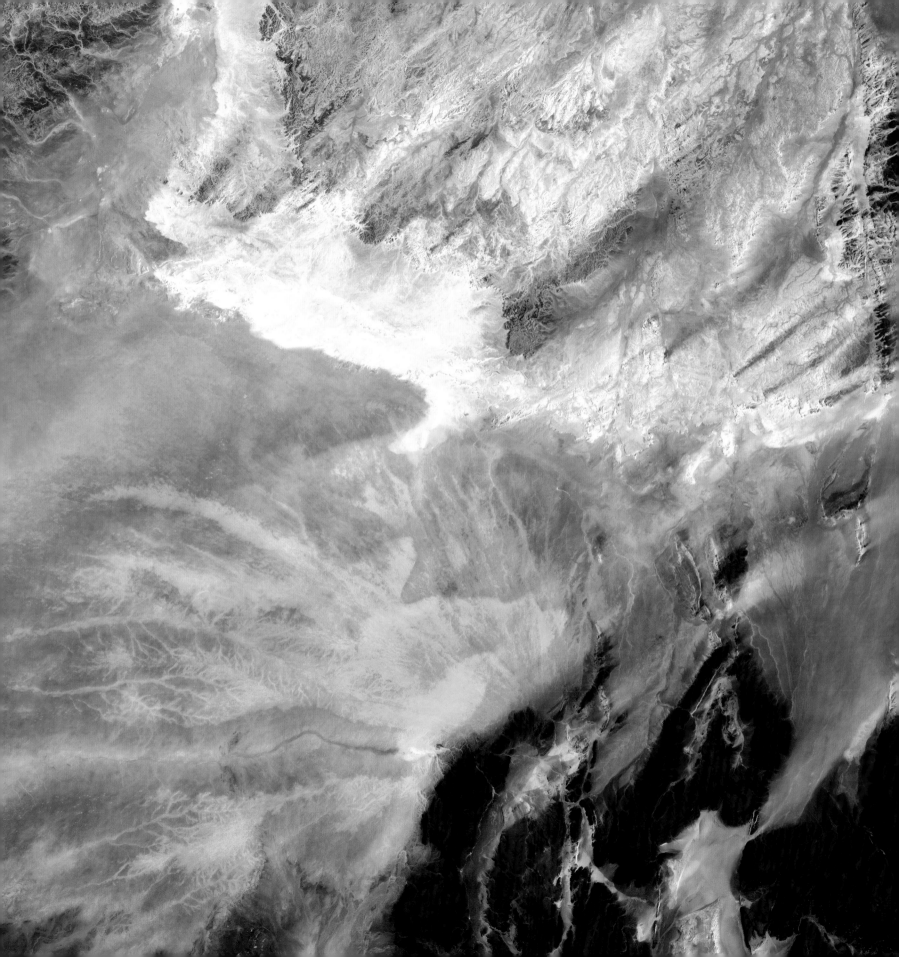

## Alluvial Fan
## China

A vast alluvial fan unfolds across the desolate landscape between the Kunlun and Altun mountain ranges that form the southern border of the Taklimakan Desert in China's Xinjiang Province. The fan is about 60 kilometers long and 55 kilometers wide at its broadest point. The left side is the active part of the fan. Water flowing down from the mountains in the many small streams appears blue in this 2002 image from the Terra satellite. Vegetation appears red and can be seen in the upper left corner of the image. Farmers take advantage of water at the foot of the fan to irrigate small fields. The "lumpy" terrain at the top of the image is composed of sand dunes at the edge of the Taklimakan, one of the largest sandy deserts on Earth. Shifting sand dunes, some reaching as high as 200 meters, cover more than 80 percent of the desert floor.

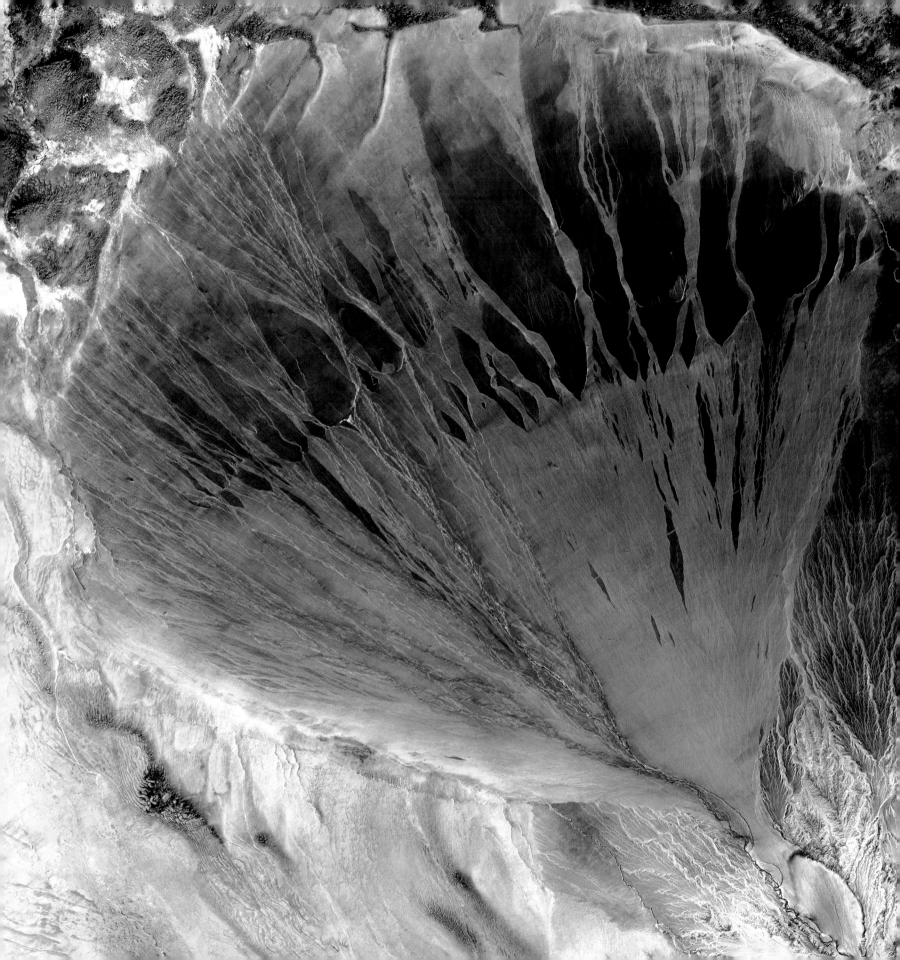

# Anti-Atlas Mountains
## Morocco

A part of the Atlas Mountains in northwest Africa, the Anti-Atlas range runs for several hundred kilometers. The range extends from the Atlantic Ocean in southwest Morocco toward the northeast, where it meets the High Atlas range closer to the Mediterranean Coast. The Anti-Atlas mountains formed as a result of continental collisions between 65 and 250 million years ago, which destroyed the then Tethys Ocean. The limestone, sandstone, claystone, and gypsum layers that formed the ocean bed were folded and crumpled to create the mountains. This Landsat 7 image from 2001 highlights some of the different rock types and illustrates the complex folding.

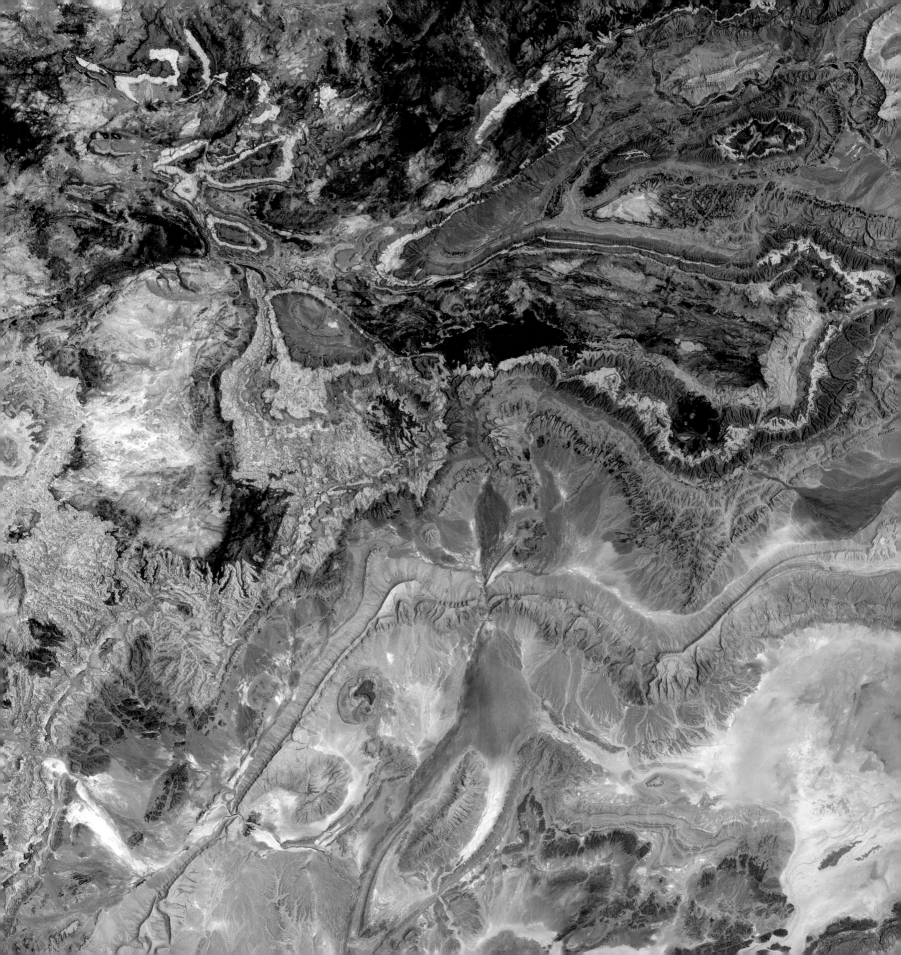

# Anyuyskiy Volcano
# Russia

Anyuyskiy Volcano lies north of the Kamchatka Peninsula in eastern Russia. Now dormant, the volcano was once active enough to send a massive lahar (an avalanche of volcanic ash and rock mixed with water) 50 kilometers down the west side of the volcano summit. The dried, hardened remains of the lahar persist today as a streak of barren rock on a landscape that is otherwise richly vegetated. In this Landsat 7 image from 2001, vegetation appears green, bare rock and ice appear bright red, and water appears navy blue. The Anyuyskiy lahar extends from the volcano's north slope, turns sharply westward, and flows toward the west-southwest. Lakes occur along the margins of the lahar, and some small lakes appear on the lahar's surface. Little vegetation has encroached on the ancient river of rock. Remote and largely inaccessible, the region is a rugged collection of towering volcanic peaks, steep valleys, and snow-fed rivers and streams.

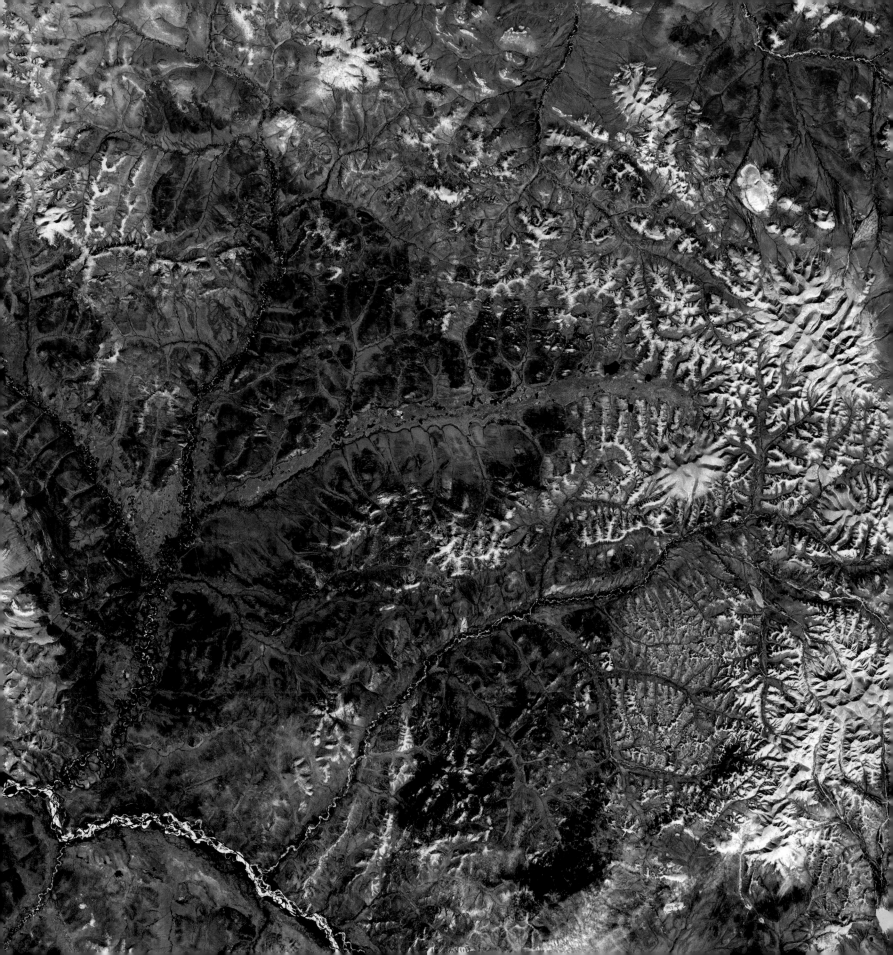

## Belcher Islands
## Canada

The Belcher Islands are spread across some 13,000 square kilometers in southeastern Hudson Bay, but within that area, only about 3,000 square kilometers are actual islands and dry land. Landsat 7 captured this image of the archipelago in August 2000, when the north's brief summer was coming to an end. The mostly brownish hues of the land areas in this image attest to a lack of vegetation, as cold temperatures prevent the growth of robust forests. The deep waters of the Hudson Bay appear almost black, with the exception of shallower areas close to land, which appear peacock blue. While they may appear delicate in this image, the Belcher Islands are composed of tough rock that has survived long stretches of geologic time. Geologists estimate that rocks in the 1,500-island archipelago range from 1.6 to 2.3 billion years old.

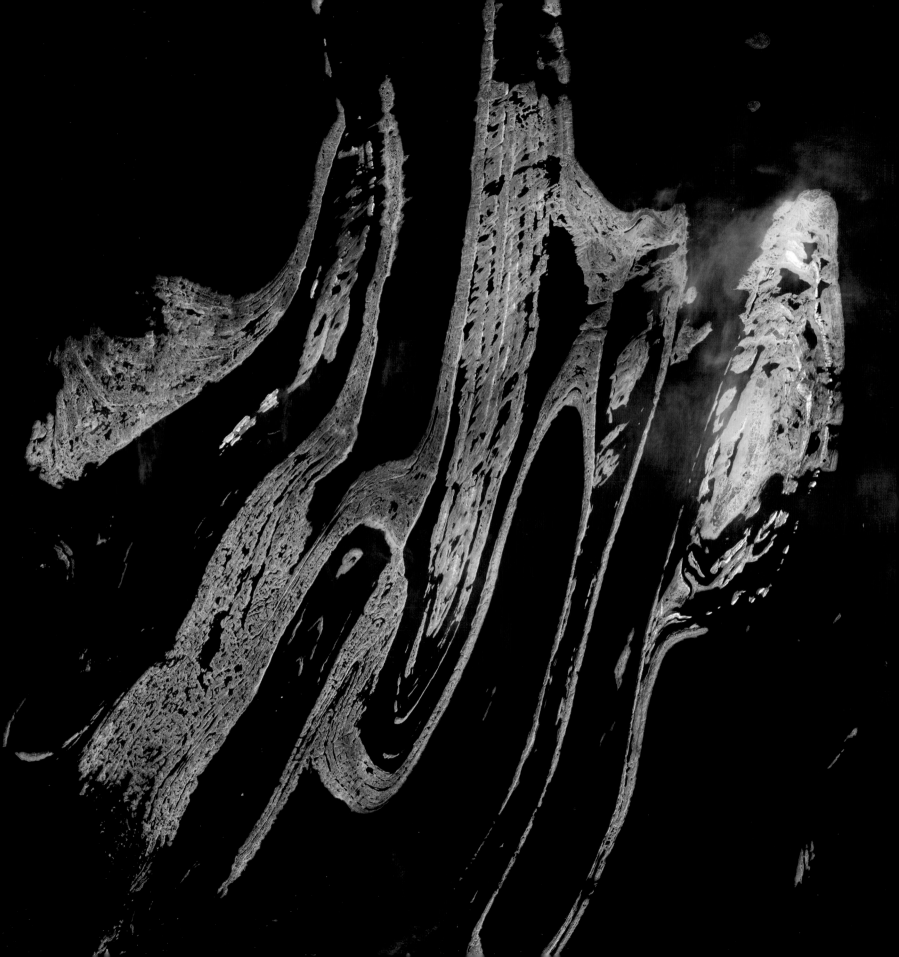

# Bogda Mountains
# China

The Turpan Depression, nestled at the foot of the Bogda Mountains in northwestern China, is a strange mix of salt lakes and sand dunes. At the bottom of the basin is Aydingkol Lake, which appears blue in this Landsat 7 image from 1999. Once a permanent lake and now a salty swamp, the lake is 155 meters below sea level, making it the third lowest place on Earth's land surface after the Dead Sea and Africa's Lake Assal. A region of temperature extremes, the Turpan Depression extends over 50,000 square kilometers. The city of Turpan, located in the higher northern part of the depression, was an important trading center on the ancient Silk Road.

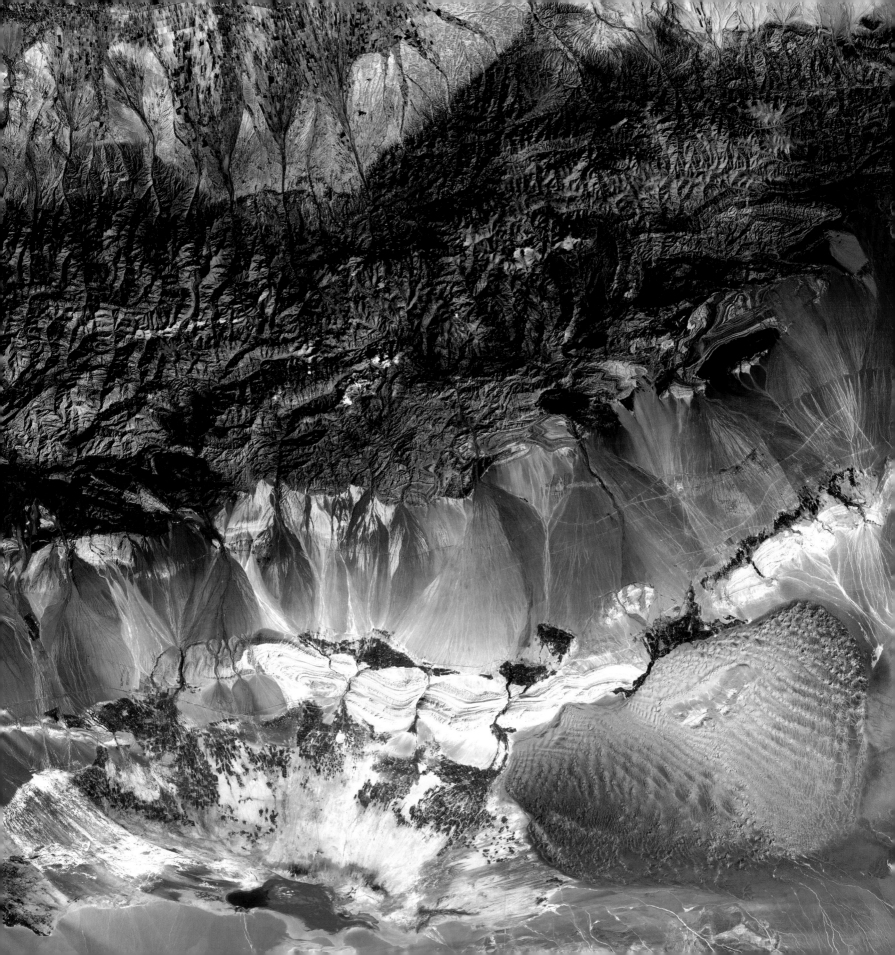

# Bombetoka Bay
# Madagascar

Bombetoka Bay is located on the northwestern coast of Madagascar near the city of Mahajanga, where the Betsiboka River flows into the Mozambique Channel. Numerous islands and sandbars have formed in the estuary due to sediment carried by the Betsiboka River as well as the push and pull of tides. The past few decades have witnessed a dramatic increase in the amount of sediment moved by the river and deposited in the estuary and offshore delta lobes, affecting agriculture, fisheries, and transportation in Mahajanga, one of Madagascar's busiest seaports. In this Terra image from 2000, dense vegetation is deep green and water is sapphire and tinged with pink where sediment is particularly thick.

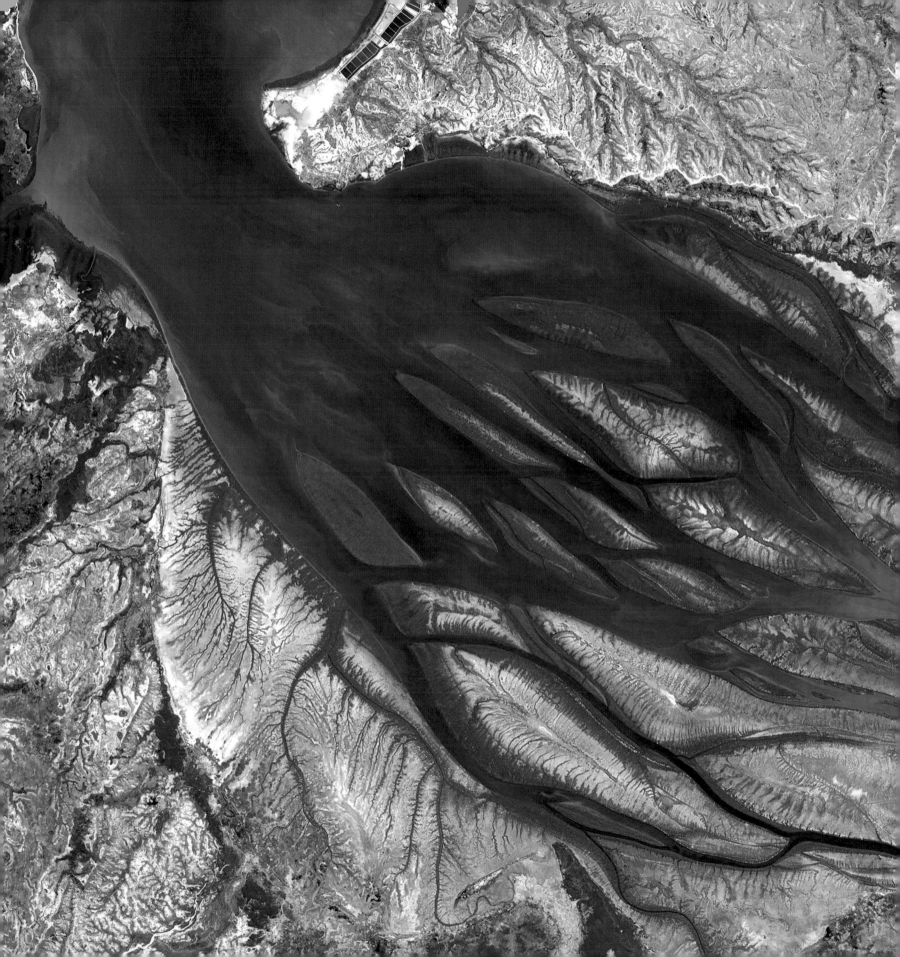

# Brandberg Massif
# Namibia

Over 120 million years ago, a single mass of granite punched through Earth's crust and intruded into the heart of the Namib Desert in what is now northern Namibia. Today, Brandberg Massif towers over the arid desert below. The locals call it Dâures—the burning mountain. The granite core of this now-dormant volcano is a remnant of a long period of tumultuous volcanic and geologic activity on Earth during which the southern supercontinent of Gondwana was splitting apart.

The mountain influences the local climate, drawing more rain to its flanks than the desert below receives. The rain filters into the mountain's deep crevices and slowly seeps out through springs. Unique plant and animal communities thrive in its high-altitude environment, and prehistoric cave paintings decorate walls hidden in the steep cliffs gouged in the mountain.

This 2002 Landsat 7 image also captured an older and more-eroded granite intrusion in the southwest. Along the Ugab River at the upper left, cracks line the brown face of an ancient plain of rock transformed into gneiss by heat, pressure, and time.

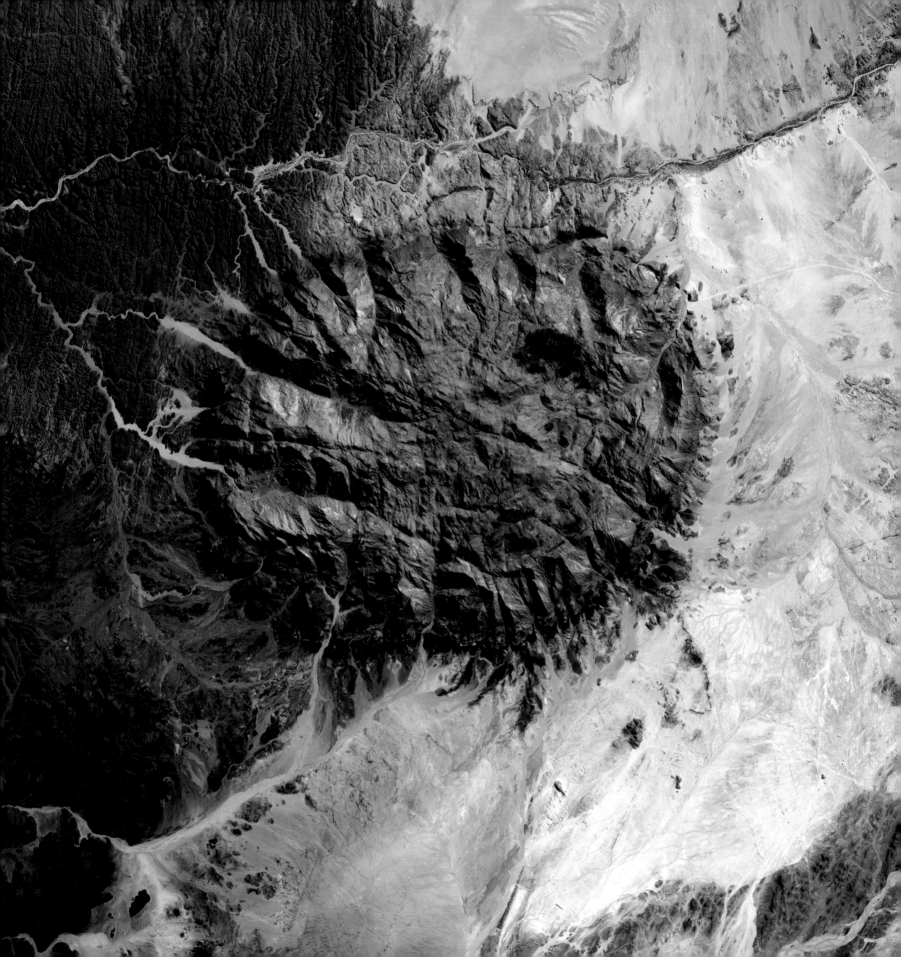

# Byrd Glacier
# Antarctica

Just as rivers drain the continents, rivers also drain Antarctica—only in this frozen landscape, the rivers are ice. In some places, steep mountains channel the flowing ice sheets and compress them into fast-moving rivers of ice. The Byrd Glacier is one such place. Byrd Glacier flows through a deep valley in the Transantarctic Mountains, covering a distance of 180 kilometers and descending more than 1,300 meters as it flows from the polar plateau (left) to the Ross Ice Shelf (right). The fast-moving stream is one of the largest contributors to the shelf's total ice volume. In this Landsat 7 image from 2000, long, sweeping flow lines are crossed in places by much shorter lines, which are deep cracks in the ice called crevasses. The conspicuous red patches indicate areas of exposed rock. Byrd Glacier is located near the principal U.S. Antarctic Research Base at McMurdo Station, and it is named after the American Antarctic explorer Richard E. Byrd.

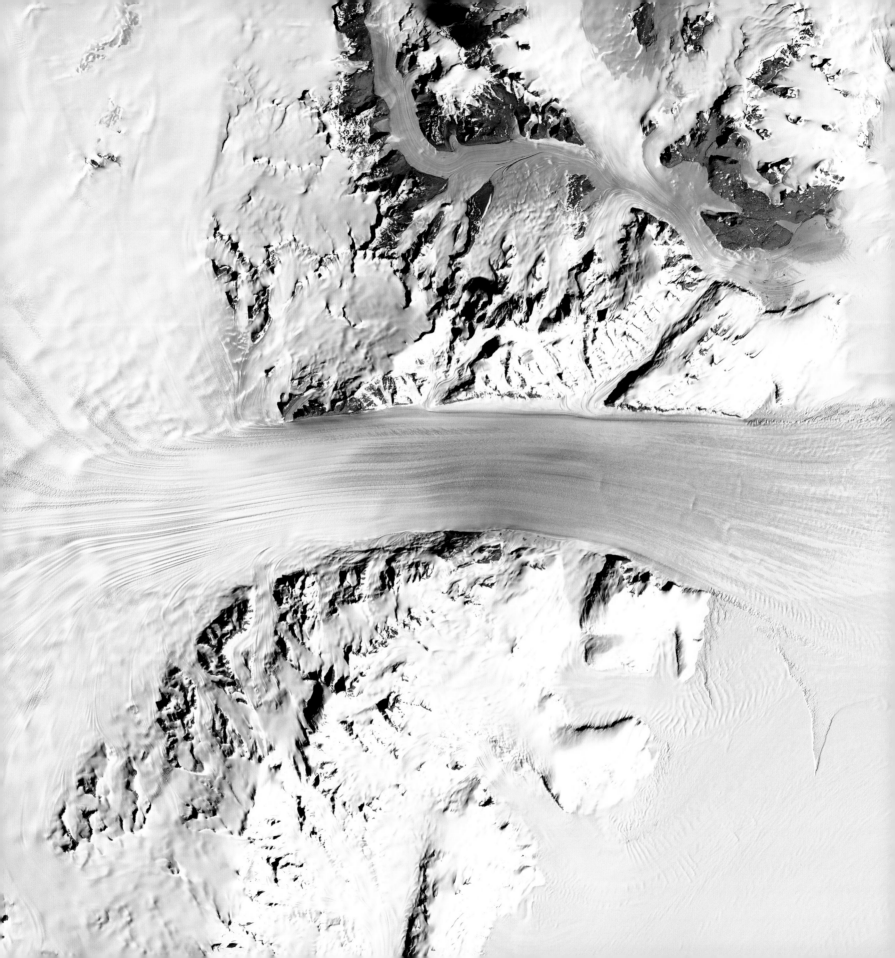

## Cape Farewell
## New Zealand

Cape Farewell and Farewell Spit were named by British explorer Captain James Cook, who said "farewell" to the land when he left New Zealand in 1770—it was the last of the islands his crew saw as they departed for Australia on the ship's homeward voyage. Its Maori name, *Onetahua*, means "heaped up sand."

Farewell Spit is located at the northwesternmost point of the South Island of New Zealand, and the spit stretches east from Cape Farewell for over 30 kilometers. The Tasman Sea is to the north and west. The spit's north side is built of sand dunes, and the southern side facing Golden Bay is largely covered with vegetation. The spit is administered as a sea bird and wildlife reserve with limited public access. The tide here can recede as much as 7 kilometers, exposing some 80 square kilometers of mudflats, a rich feeding ground for the many sea birds in the area. Terra acquired this image in 2001.

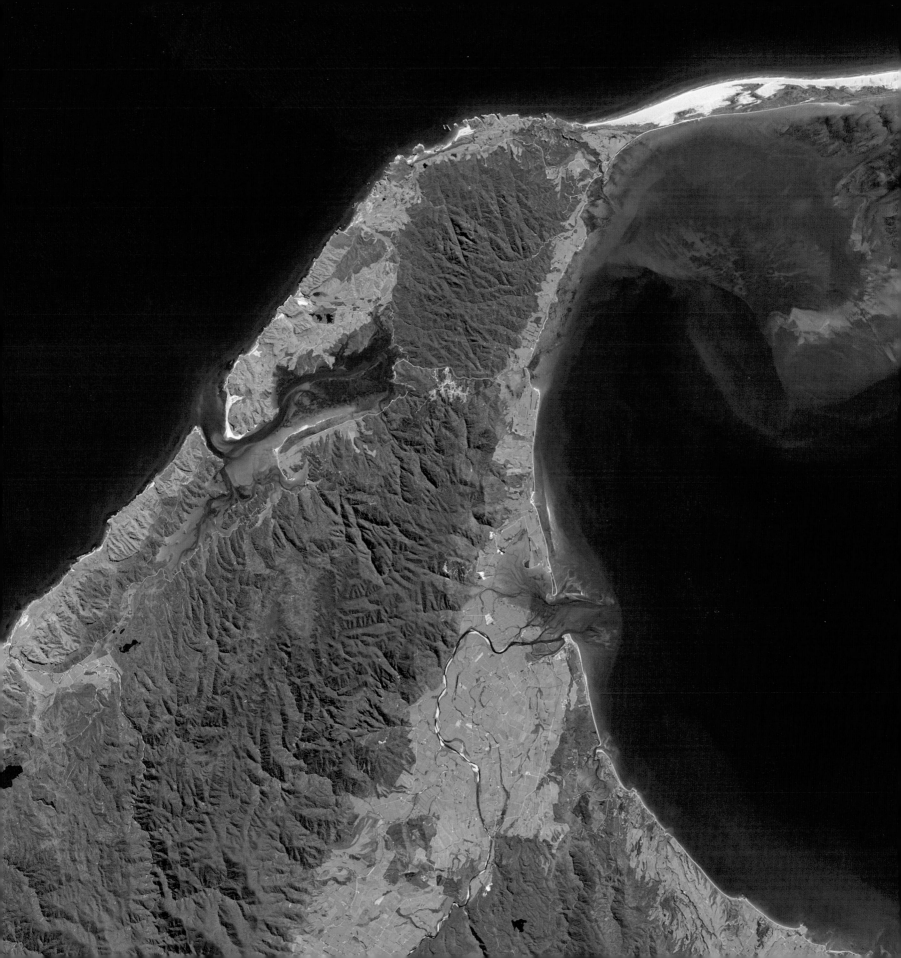

## Carbonate Sand Dunes
## Atlantic Ocean

In this 2002 Terra image, calcium carbonate sand dunes are apparent in the shallow waters of Tarpum Bay, southwest of Eleuthera Island in the Bahamas. The sand making up the dunes comes from the erosion of limestone coral reefs, shaped into dunes by ocean currents.

Eleuthera Island is one of the larger "out" islands of the Bahamas. The island itself consists mainly of low, rounded limestone hills, and the highest elevation of the island is about 60 meters. It has a rough, karst topography with caves, sinkholes, and cenotes. The island is surrounded by coral reefs and pink sand beaches.

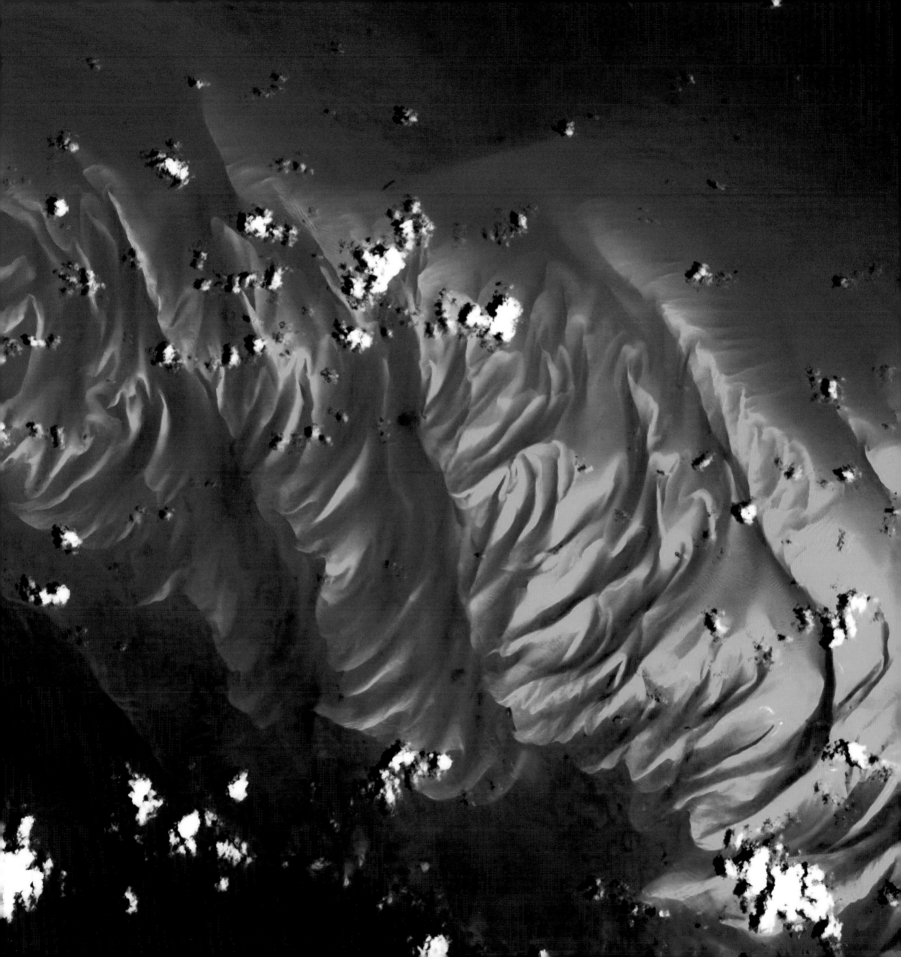

# Carnegie Lake
# Australia

Ephemeral Carnegie Lake, in Western Australia, fills with water only during periods of significant rainfall. In dry years, it is reduced to a muddy marsh. When full, it can cover an area of about 6 square kilometers. In this Landsat 7 image from 1999, flooded areas appear dark blue or black. Vegetation appears in shades of dark and light green, and sands, soils, and minerals appear in a variety of colors.

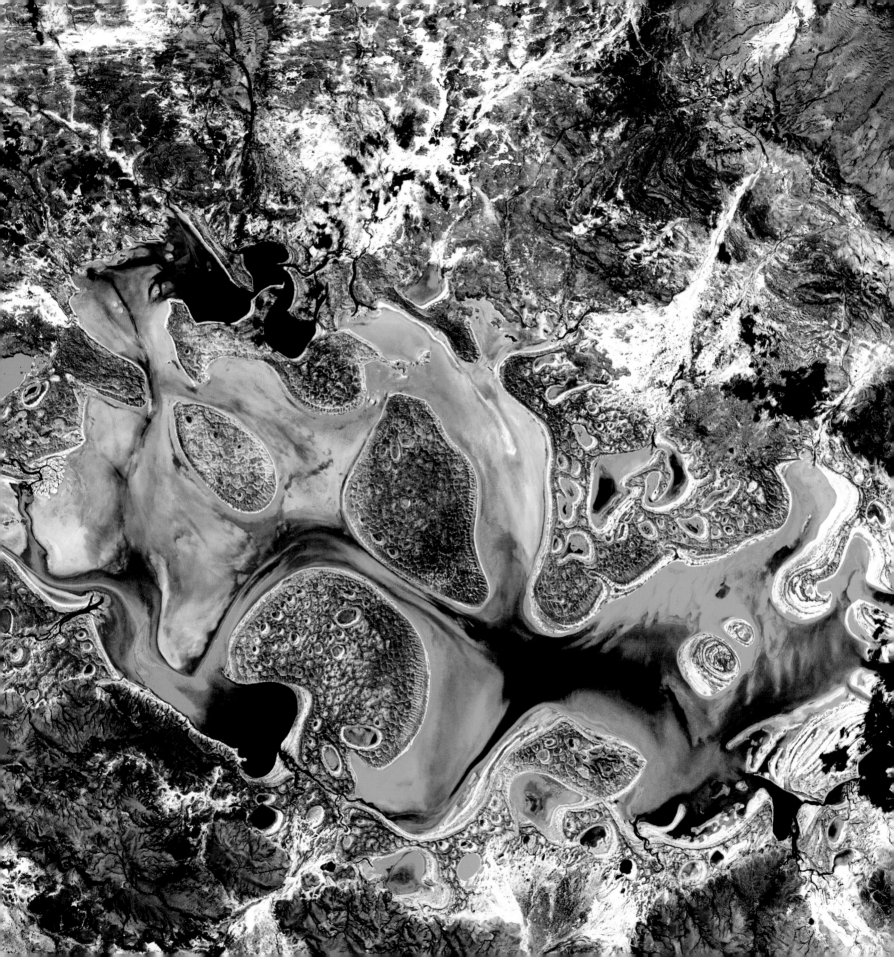

# Dardzha Peninsula
# Turkmenistan

Jutting into the Caspian Sea, the Dardzha Peninsula in western Turkmenistan lies among the shallow, coastal terraces in the sea's southeast portion. Strong winds create huge sand dunes near the water, some of which are partly submerged. Farther inland, the dunes transition into the low sand plains of the Karakum Desert, which covers 70 percent of the country. Landsat 7 captured this image in 2001.

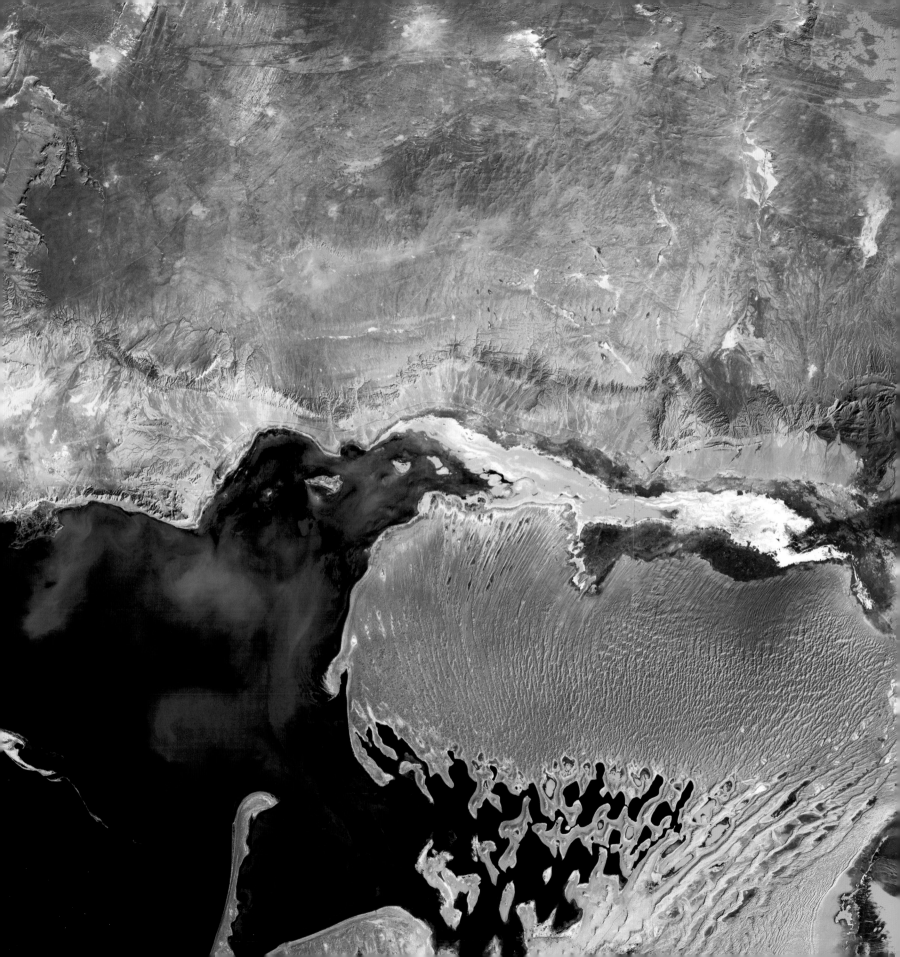

# Dasht-e Kavir
# Iran

The Dasht-e Kavir, or Great Salt Desert, is the larger of Iran's two major deserts, which occupy most of the country's central plateau. Located in north-central Iran, the mostly uninhabited desert is about 800 kilometers long and 320 kilometers wide. Once situated beneath an ancient inland sea, the arid region is now covered with salt deposits and is known for its salt marshes (kavirs), which can act like quicksand. From wild sheep and leopards to gazelles and lizards, there is a range of wildlife in the mountainous areas and parts of the steppe and desert areas of the central plateau. This 2000 Landsat 7 image shows the intricately folded sediments and colorful formations that now blanket the surface of this barren landscape.

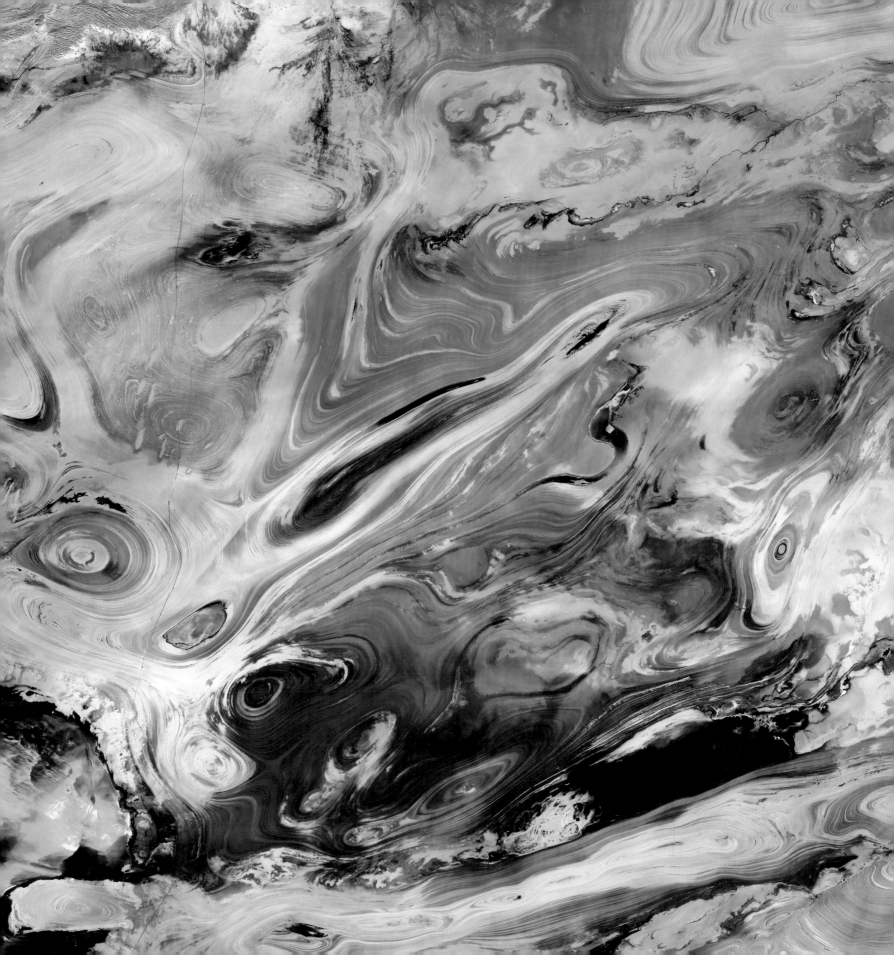

# Desolation Canyon
# United States

Nearly as deep as the Grand Canyon, Desolation Canyon is one of the largest unprotected wilderness areas in the American West. In this Landsat 7 image from 2000, the Green River in Utah flows south across the Tavaputs Plateau (top) before entering the canyon (center).

Desolation Canyon has a rich history. Geologist and explorer John Wesley Powell named the canyon. During two river expeditions in 1869 and 1871, Powell's team mapped the Green River for the first time before heading down the Colorado River to the Grand Canyon. People of the Fremont culture inhabited the canyon and the plateau from about 200 to 1300 C.E. The present-day Ute Tribe owns the land along the east side of the river. Fremont and Ute pictographs and petroglyphs are abundant in Desolation and its numerous tributary canyons. The U.S. declared Desolation Canyon a National Historic Landmark in 1968.

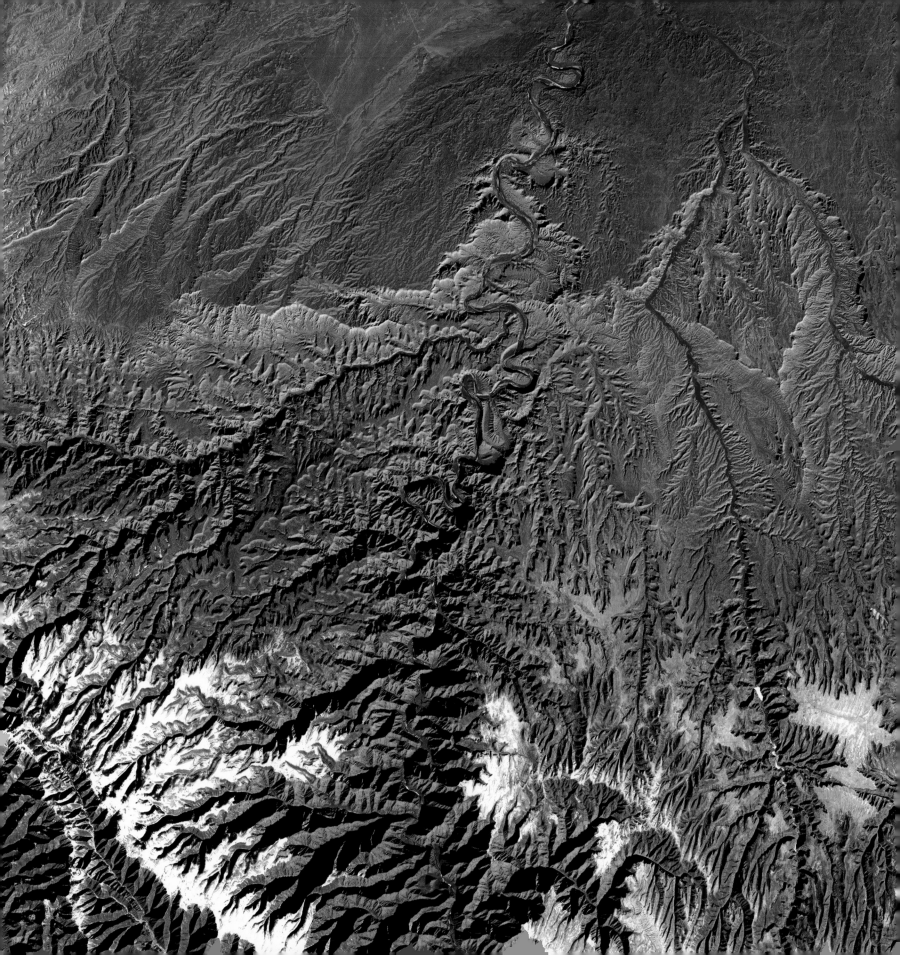

# East African Rift
# Kenya

The East African Rift is a classic example of rifting, an area where tectonic plates move apart from each other. Rifts often form stunning geological features. The East African Rift is characterized by deep valleys in the rift zone, sheer escarpments along the faulted walls of the rift zone, a chain of lakes within the rift, volcanic rocks that have flowed from faults along the sides of the rift, and volcanic cones where magma flow was most intense. This Terra image from 2002 includes most of these features near Lake Begoria in Kenya.

This rift is a narrow zone in which the African Plate is in the process of splitting into two new tectonic plates called the Somali Plate and the Nubian Plate. Most of the lakes in this rift are highly saline due to evaporation in the hot temperatures characteristic of climates near the equator. The East African Rift runs from the Afar Triple Junction southward through eastern Africa and has been a rich source of fossils that allow for the study of human evolution.

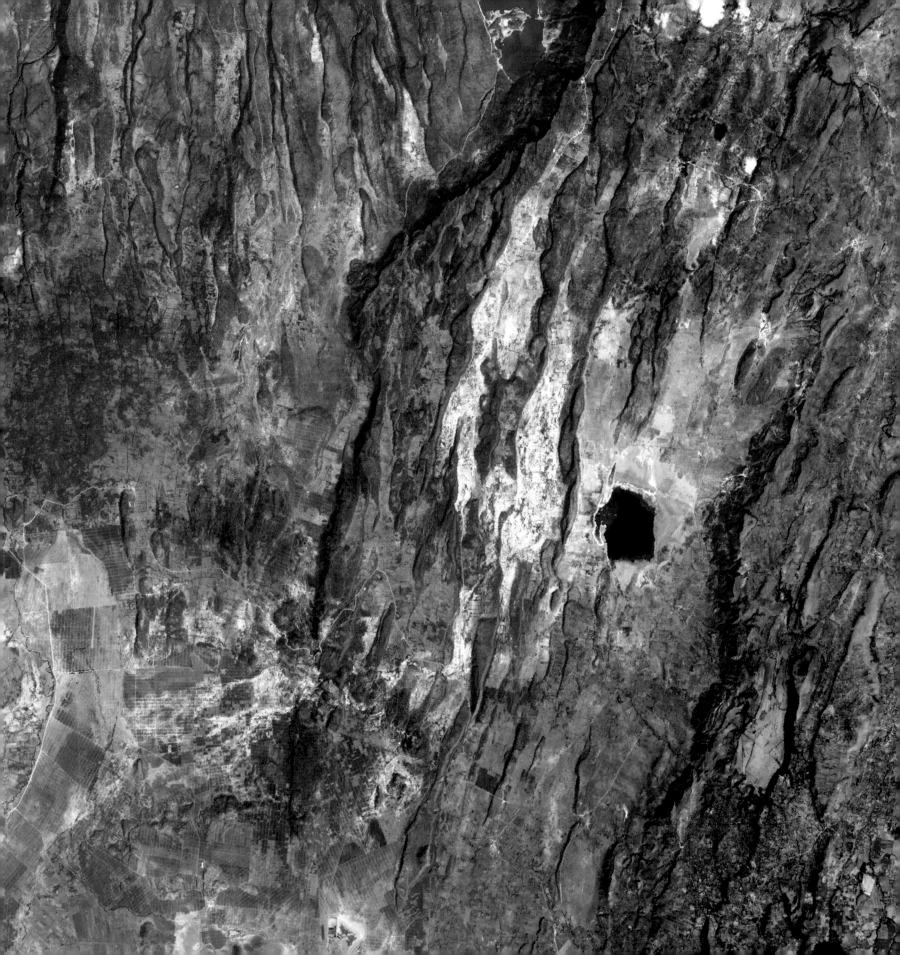

# Edrengiyn Nuruu
# Mongolia

Edrengiyn Nuruu is a mountainous region located in southwest Mongolia. The area has an average elevation of over 1,540 meters above sea level and forms a transitional boundary between the Mongolian steppes to the north and the arid deserts of China to the south. The area's climate is classified as a midlatitude desert with a boreal wet forest biozone, and the foothills serve as one of just four known habitats of the wild camel. Landsat 7 acquired this image in 1999.

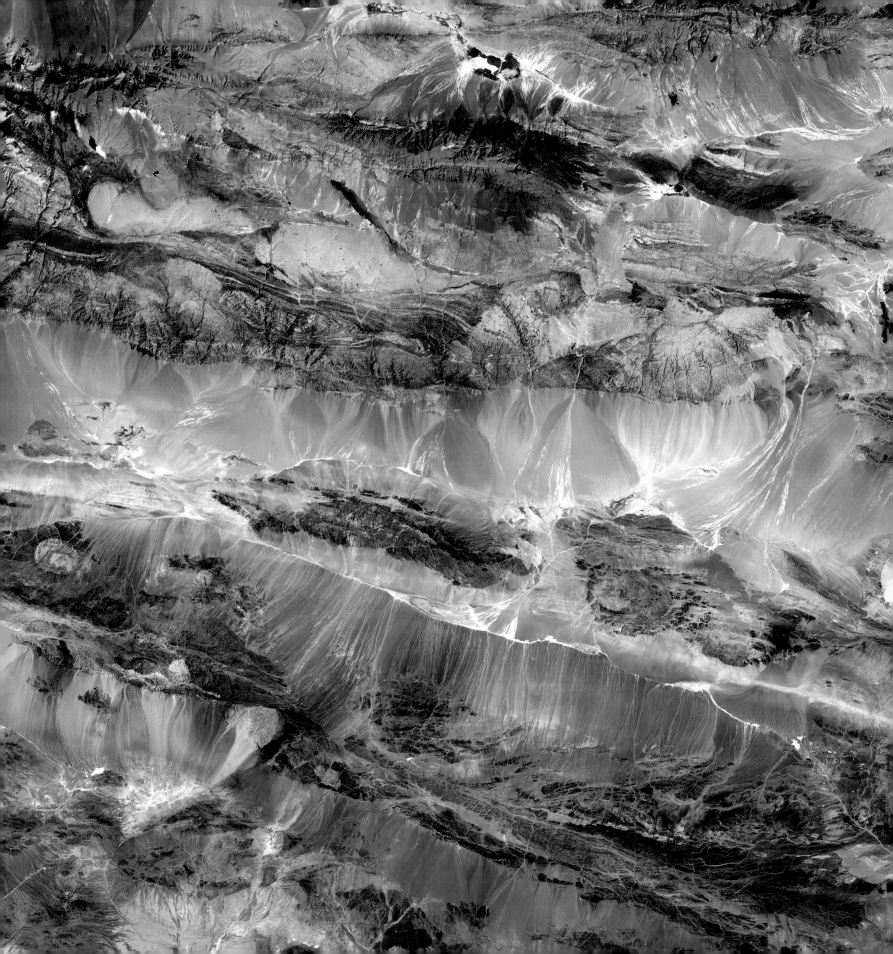

# Erg Chech
# Algeria

In this Landsat 7 image from 2003, the amber and caramel lattices seen are large, linear sand dunes in the Erg Chech dune sea located in the Sahara region of western Algeria. An erg, meaning dune field in Arabic, is a wide, flat area of desert covered with wind-blown sand and little vegetation cover. The dunes are formed when large amounts of transported sand are halted by topographic barriers. The largest dunes can take up to a million years to build. Ergs are also found on other celestial bodies such as Venus, Mars, and Saturn's moon Titan.

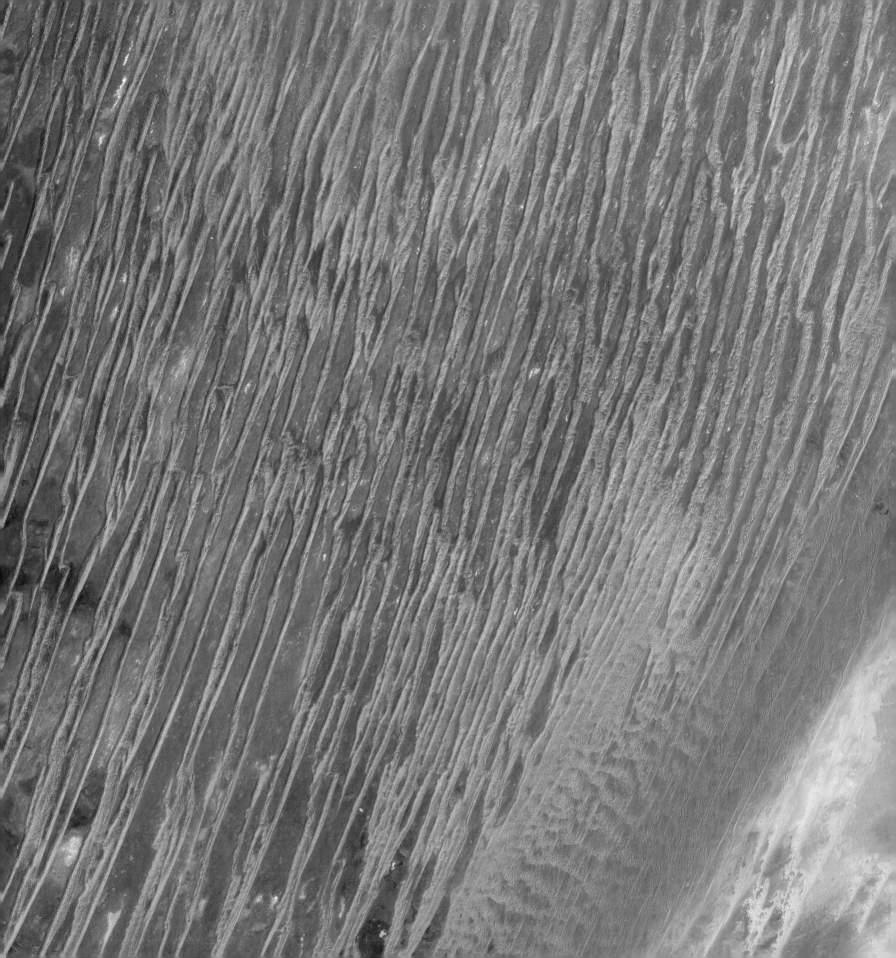

# Erg Iguidi
# Algeria and Mauritania

Ridges of wind-blown sand flow across Erg Iguidi, a Saharan sand sea. Erg Iguidi is one of several Saharan ergs and extends from Algeria into Mauritania in northwestern Africa. The dunes (in yellow) are about 250 meters wide, rising high above the sand sea. Winds blow from the northwest to the southeast, often under the influence of oceanic monsoons. In this 1985 Landsat 5 image, dunes in the center and upper left lie atop black sandstone rock while the light blue and white areas are edges of the chalk plateaus in the region.

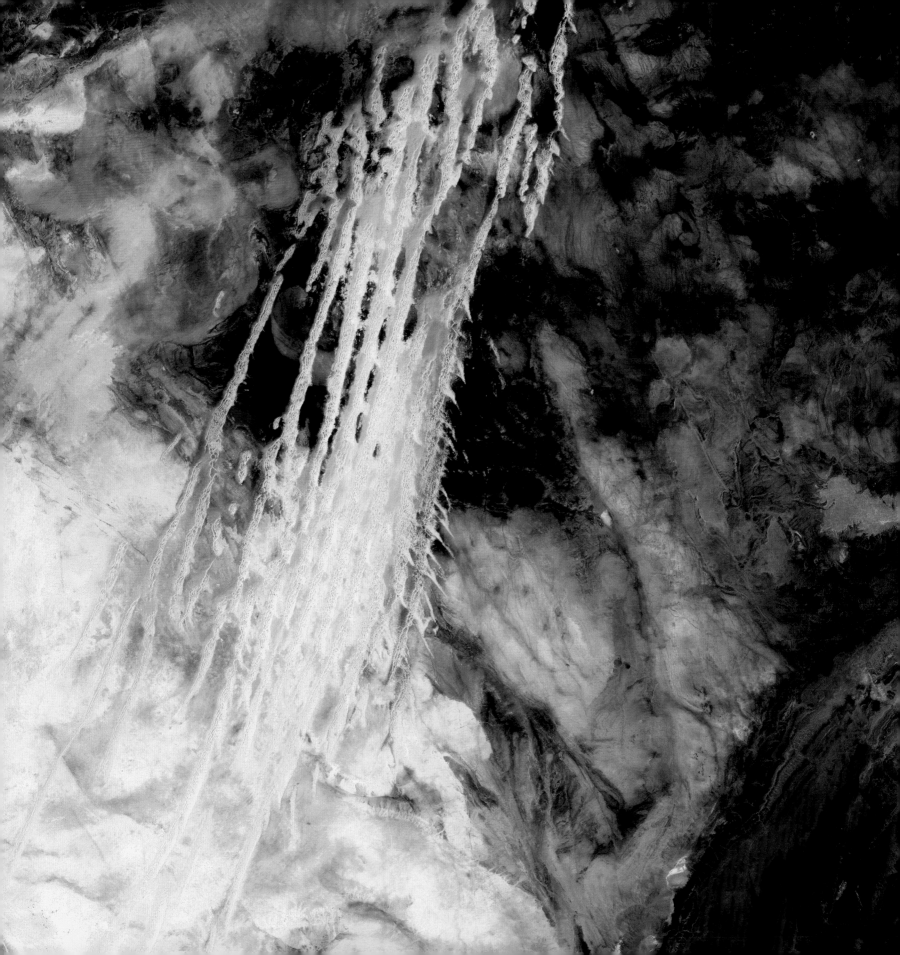

# Erongo Massif
# Namibia

The dark heart in this Landsat 7 image from 2003 is the Erongo Massif, a prominent, sheer-walled semicircular mountain 30 kilometers in diameter. The massif rises 1,200 meters above the Namib Desert to the west and a mixed woodland savannah to the east. The mountain is an eroded relic of a volcano that was active some 140 to 150 million years ago but collapsed upon itself with the weight of the overlying magma. Eons of erosion by wind and wind-blown sand gradually exposed the long-dead volcano's core of granite and basalt. Minerals have been collected in the Erongo region for nearly 90 years, including some of the finest aquamarine, schorl, and jeremejevite. The area has a confluence of ecosystems that are home to a vast array of plant, reptile, mammal, and bird species, some endemic to Namibia.

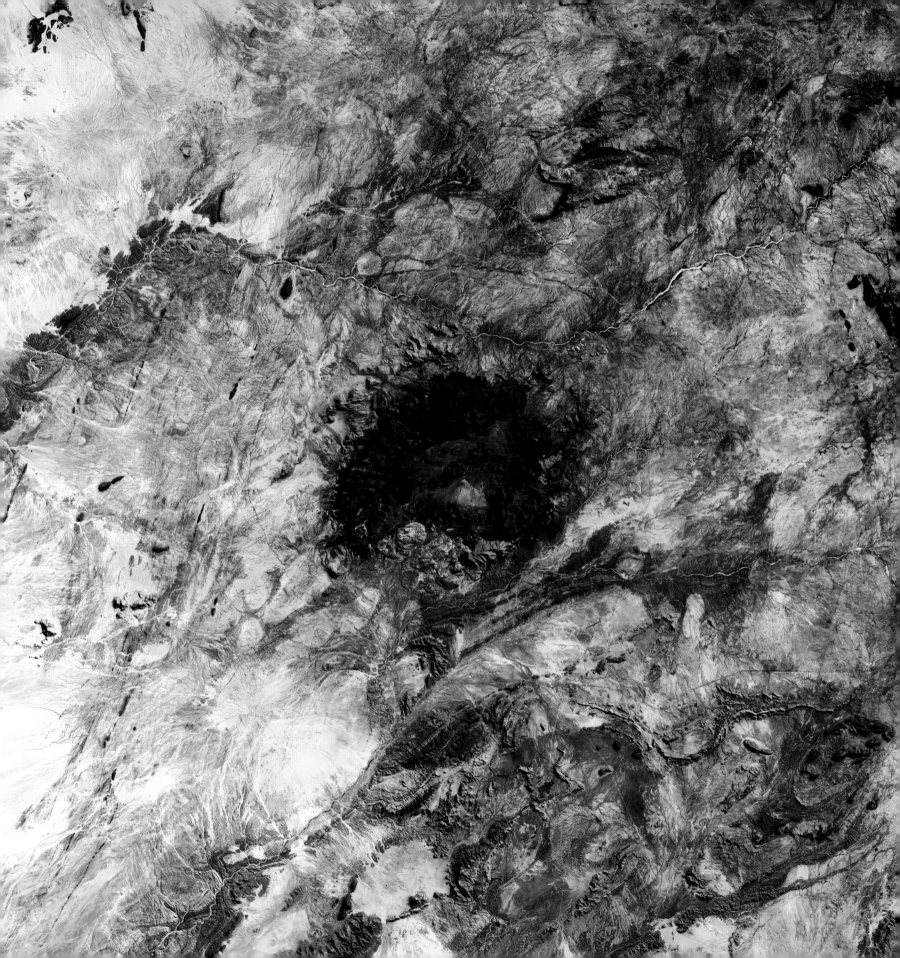

# Garden City
# United States

Garden City, Kansas, has a semi-arid steppe climate with hot, dry summers and cold, dry winters. Center-pivot irrigation systems created the circular patterns near Garden City, seen here from Landsat 7 in September 2000. The red circles indicate irrigated crops of healthy vegetation, and the light-colored circles denote harvested crops. The 19th-century Santa Fe Trail through central North America that connected Franklin, Missouri, with Santa Fe, New Mexico, passed through Garden City.

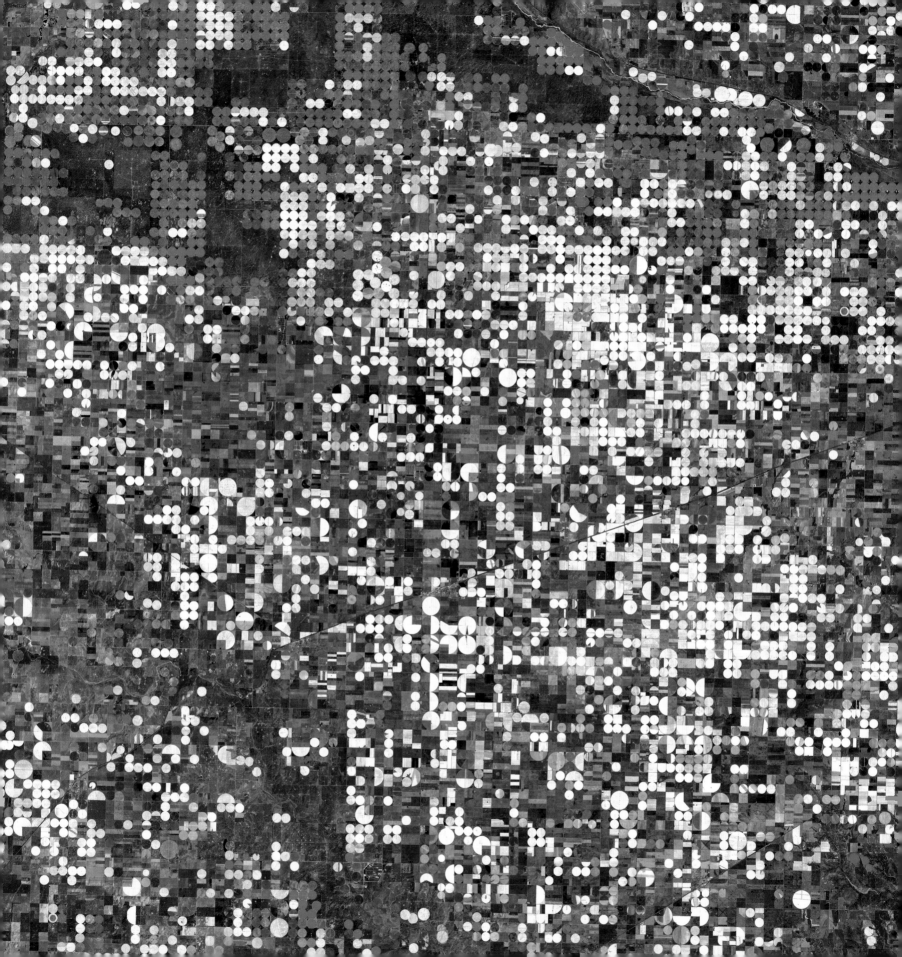

# Grand Bahama Bank
# Atlantic Ocean

Near Florida and Cuba, the underwater terrain is hilly and the crests of many of these hills compose the islands of the Bahamas. A striking feature of this 2009 Aqua image is the Great Bahama Bank, a massive underwater hill underlying Andros Island in the west, Eleuthera Island in the east, and multiple islands in between. To the north, another bank underlies a set of islands, including Grand Bahama. The varied colors of these banks suggest that their surfaces are somewhat uneven. The banks' distinct contours, sharply outlined in dark blue, indicate that the ocean floor drops dramatically around them. Over the banks, the water depth is often less than 10 meters, but the surrounding basin plunges to depths as low as 4,000 meters.

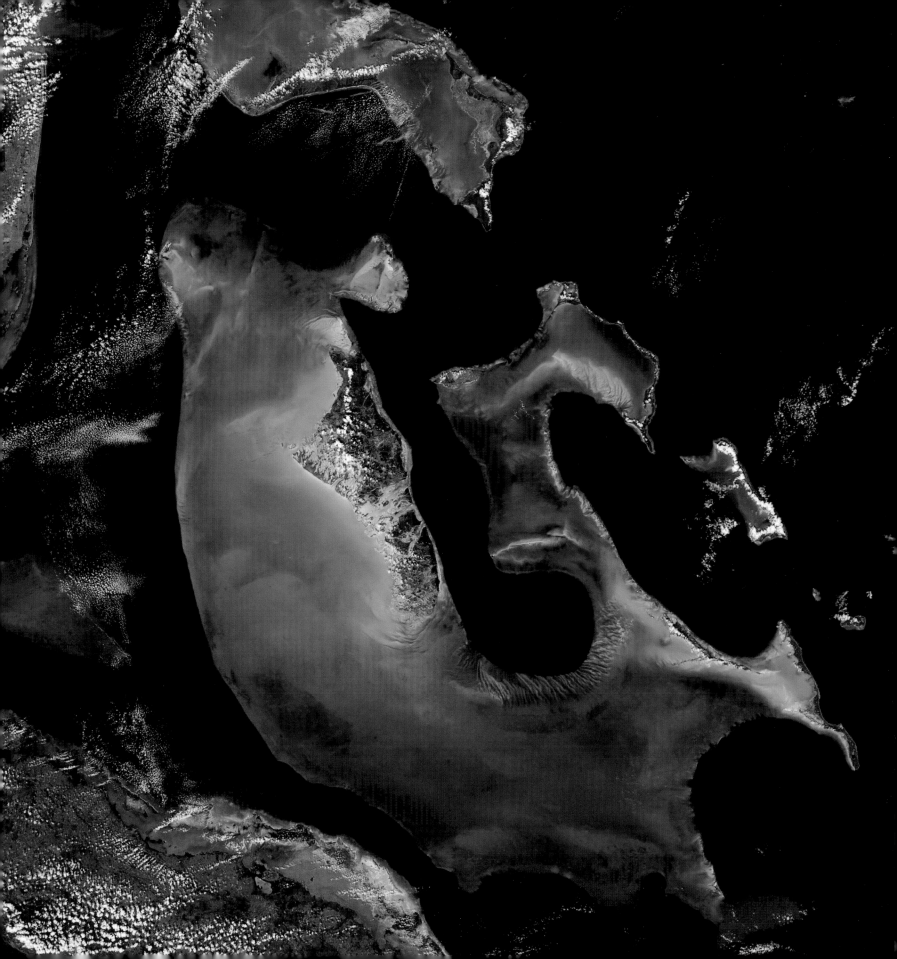

## Gravity Waves
## Above the Indian Ocean

In this Terra image from 2003, a fingerprint-like feature occurs over a deck of marine stratocumulus clouds. The feature is the result of gravity waves. Similar to the ripples that occur when a pebble is thrown into a still pond, gravity waves sometimes appear when the relatively stable and stratified air masses associated with stratocumulus cloud layers are disturbed by a vertical trigger, such as the underlying terrain, a thunderstorm updraft, or some other vertical wind shear. The stratocumulus cellular clouds that underlie the wave feature are associated with sinking air that is strongly cooled at the level of the cloud tops—such clouds are common over midlatitude oceans when the air is unperturbed by cyclonic or frontal activity.

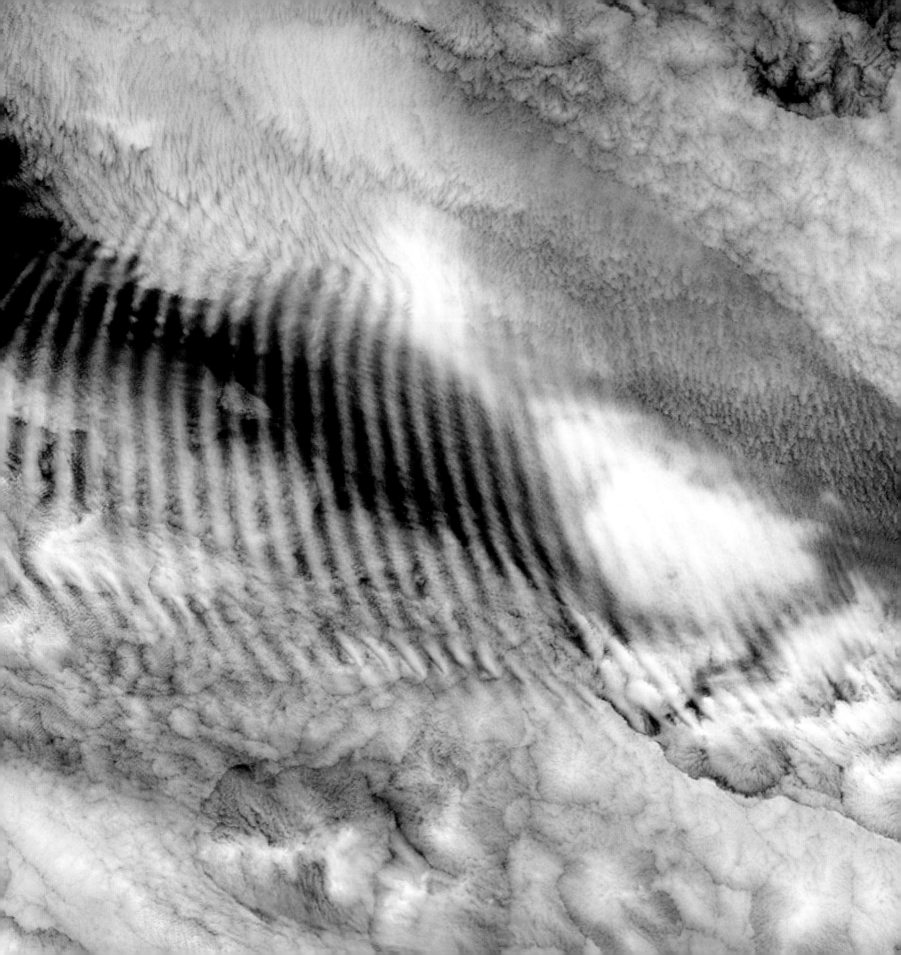

# Great Salt Desert
# Iran

A mix of salt marshes, mudflats, wadis, steppes, and desert plateaus color the landscape of Iran's Great Salt Desert, Dasht-e Kavir. The region covers an area of more than 77,000 square kilometers. Dramatic daily temperature swings and violent storms are the norm, and extreme heat leaves the marshes and mud grounds with large crusts of salt. Some vegetation has adapted to the hot, arid climate and to the saline soil. Some wildlife live in parts of the steppe and desert areas of the central plateau, while others are common in the mountainous areas. Human settlement is largely restricted to some oases. Landsat 7 acquired this image in 2003.

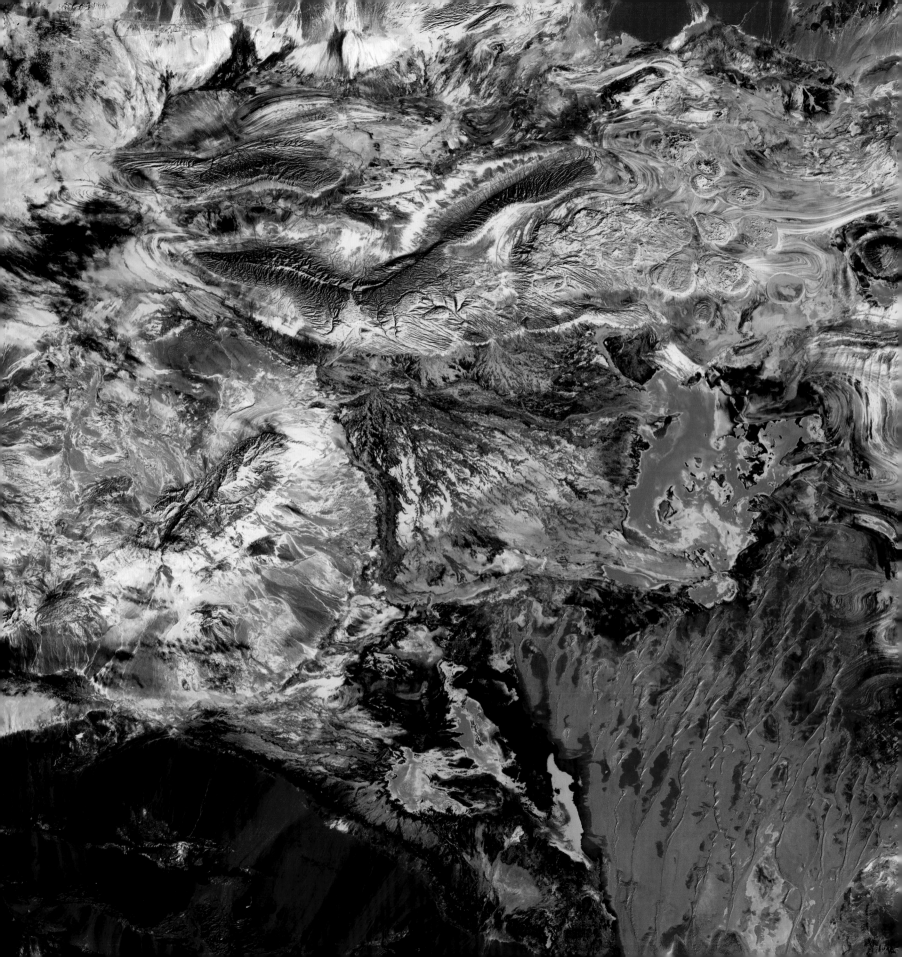

# Himalayas
# Central Asia

The soaring, snow-capped peaks and ridges of the eastern Himalaya Mountains create an irregular patchwork between major rivers in Tibet and southwestern China. Covered by snow and glaciers, the mountains here rise to altitudes of more than 5,000 meters. Vegetation at lower elevations is colored red in this Terra image from 2001. The Himalayas are made up of three parallel mountain ranges that together extend more than 2,900 kilometers. Uplift of the Himalayas continues today, at a rate of several millimeters per year, in response to the continuing collision of the Indian and Eurasian Plates that began about 70 million years ago.

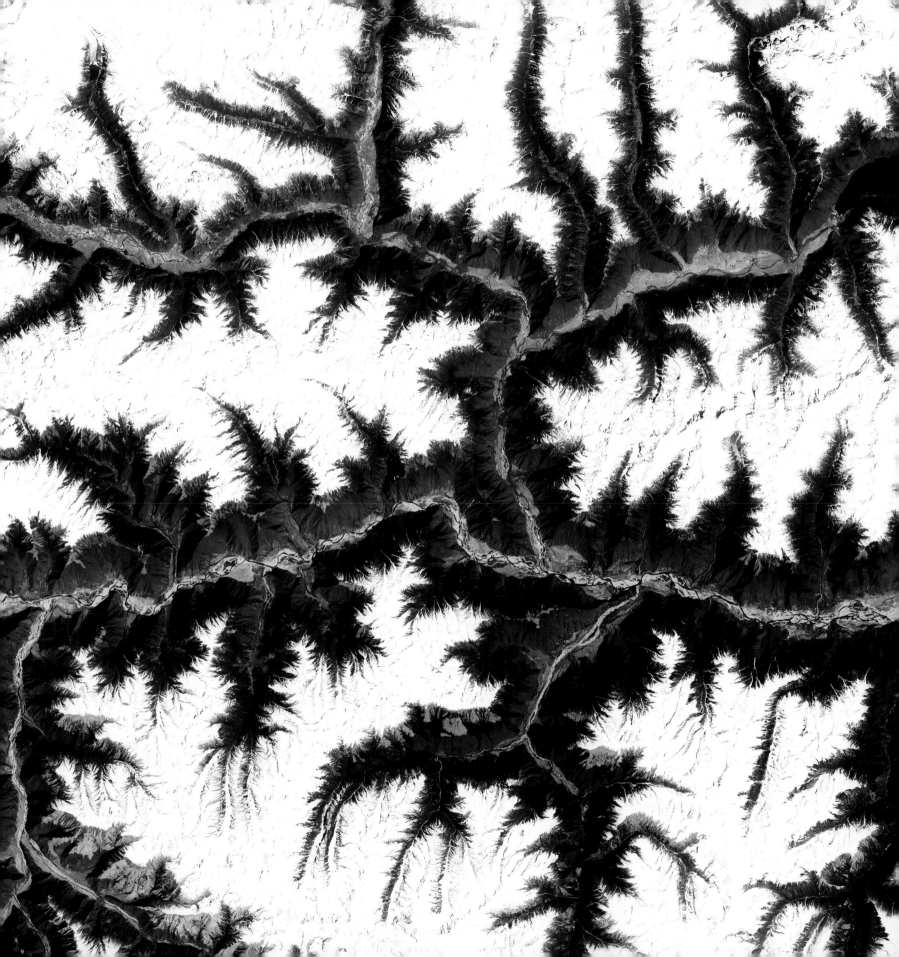

# Ice Waves
# Greenland

The undulating swirls shown here along the eastern coast of Greenland are slurries of sea ice, newly calved icebergs, and older weathered bergs. During the summer melting season, the southward-flowing East Greenland Current twirls these mixtures into stunning shapes. The East Greenland Current is the major current for transporting sea ice from Greenland into the North Atlantic. The rush of fresh water on an annual basis contributes to the low salinity and cold temperature of the current. In the center of this 2001 Landsat 7 image, the exposed rock of mountain peaks, tinted red, appears as an intricate network of glacier-cut fjords.

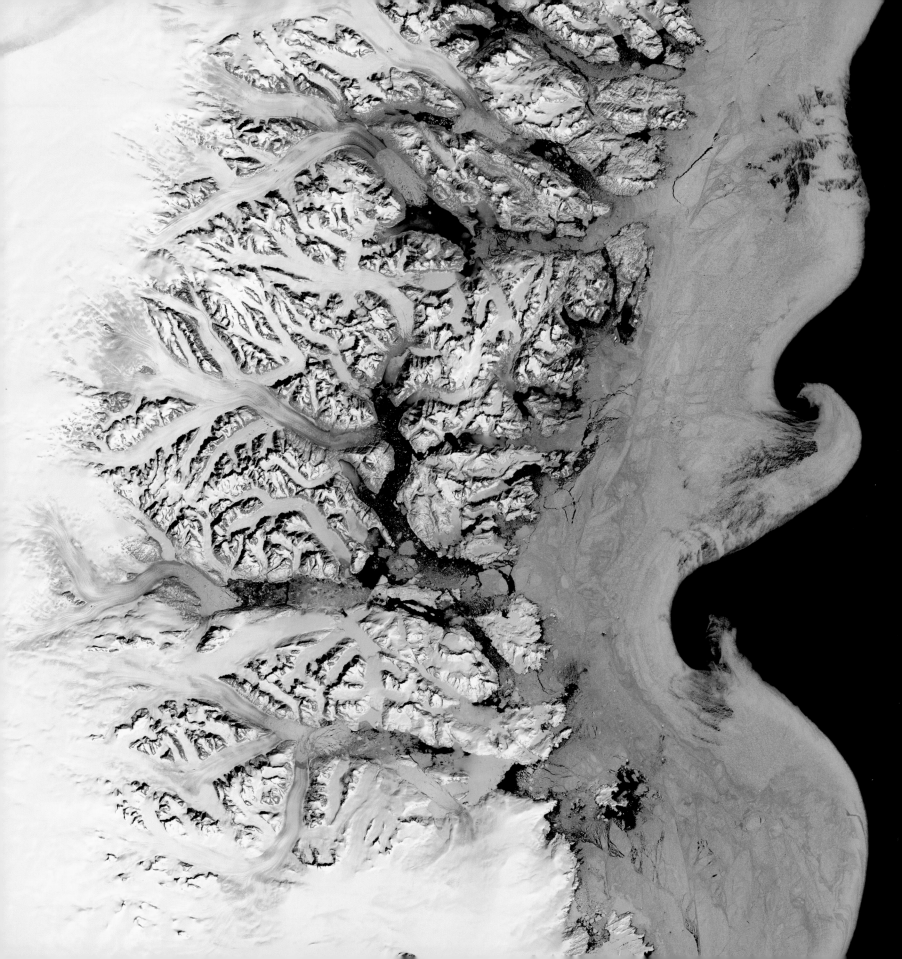

# Isla Espíritu Santo and Isla Partida
# Mexico

Isla Espíritu Santo and Isla Partida are islands in the Gulf of California, located off the coast of the Mexican state of Baja California Sur. Isla Partida is the northern island of the group, which is about 32 kilometers long and 10 kilometers across at the widest point. Depending on the tides, the islands are connected by a narrow isthmus or separated by a shallow channel.

Protected as a United Nations Educational, Scientific and Cultural Organization (UNESCO) Biosphere Reserve, the islands are made up of alternating layers of black lava and pink volcanic ash. On the eastern side, steep cliffs drop sheerly into the water. The western side of the islands is digitate, or fingerlike, with a series of rocky points separated by deep, shallow bays. Thin, xeric vegetation gives the island its greenish color in this 2002 Terra image, while bare ground appears pinkish orange. Small mangrove swamps tucked into the west coast bays appear bright green. The creamy-white beaches are composed of fine-grained, coralline sand.

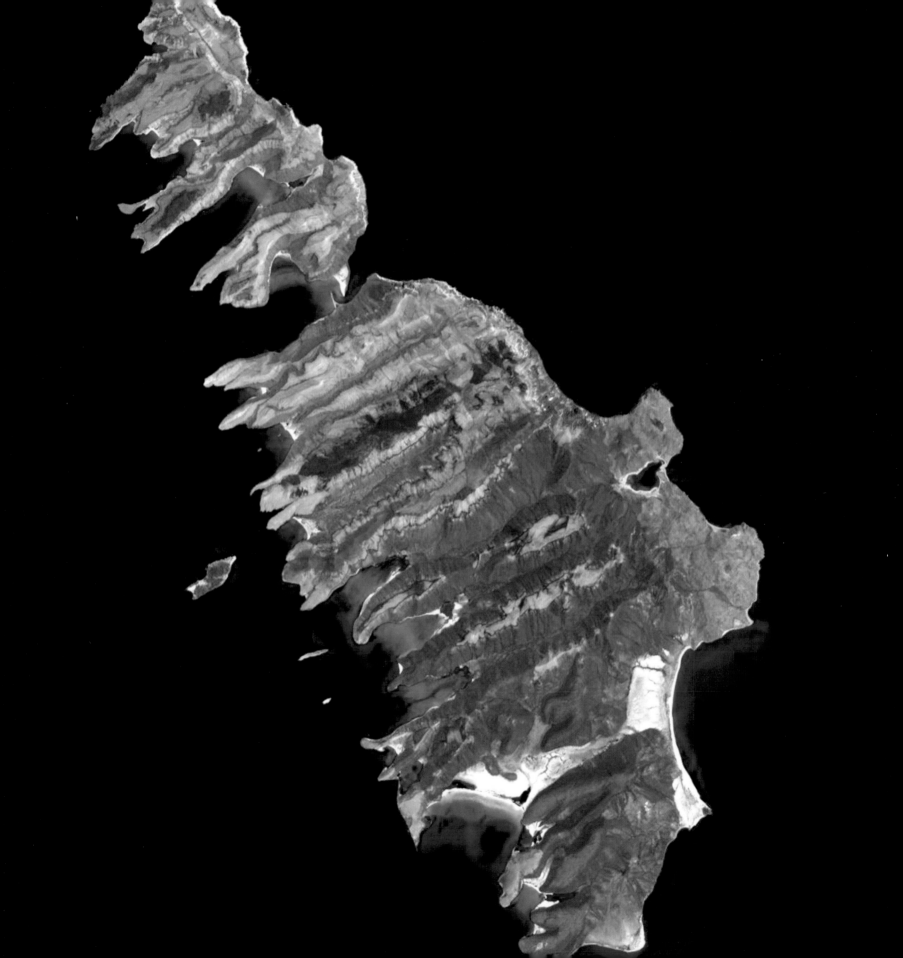

# Jebel Uweinat
# Egypt

Rivers of sand sweep around the mountainous outcrops of Jebel Uweinat in this Terra image from 2002. Jebel Uweinat towers 1,934 meters above the barren plains of the Libyan Desert, the eastern third of the Saharan Desert. Located at the intersection of the Libyan, Egyptian, and Sudanese borders, the Jebel Uweinat highlands foster more rainfall and cooler temperatures than the surrounding desert, supporting woodlands and shrublands of palms, acacias, Saharan myrtle, oleander, and tamarix as well as several endemic and rare plant species.

The mountains are remnants of an ancient granitic dome. The western part of the massif consists of intrusive granite arranged in a ring shape about 25 kilometers in diameter, ending in three wadis (dry, seasonal riverbeds) towards the west. Its eastern side consists of sandstone and includes a permanent oasis. The area is notable for its petroglyphs. The sandstone provided a canvas for Bushmen-style engravings of lions, giraffes, ostriches, gazelles, cows, and human figures.

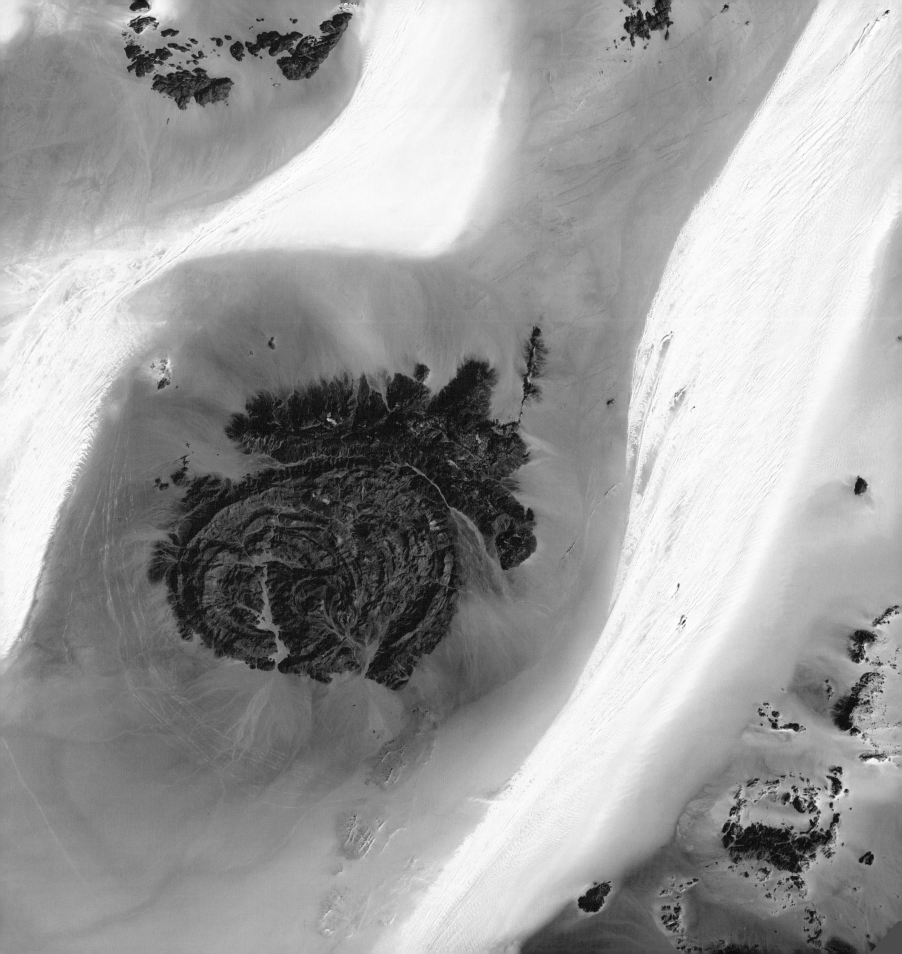

# Kalahari Desert
# Southern Africa

Derived from a Tswana word meaning "waterless place," the Kalahari Desert is a large stretch of semiarid, sandy savannah that covers part of Botswana, Namibia, and South Africa. The Kalahari has vast areas covered by red sand without any permanent surface water. The Kalahari is regarded as a semidesert because some portions support more vegetation from erratic rainfall, while other areas are truly arid. In this Landsat 7 image from 2000, the Nossob River cuts through colorful streaks of sand deposits. The red dot near the river in the center of this image represents a farm made possible by a center-pivot irrigation system.

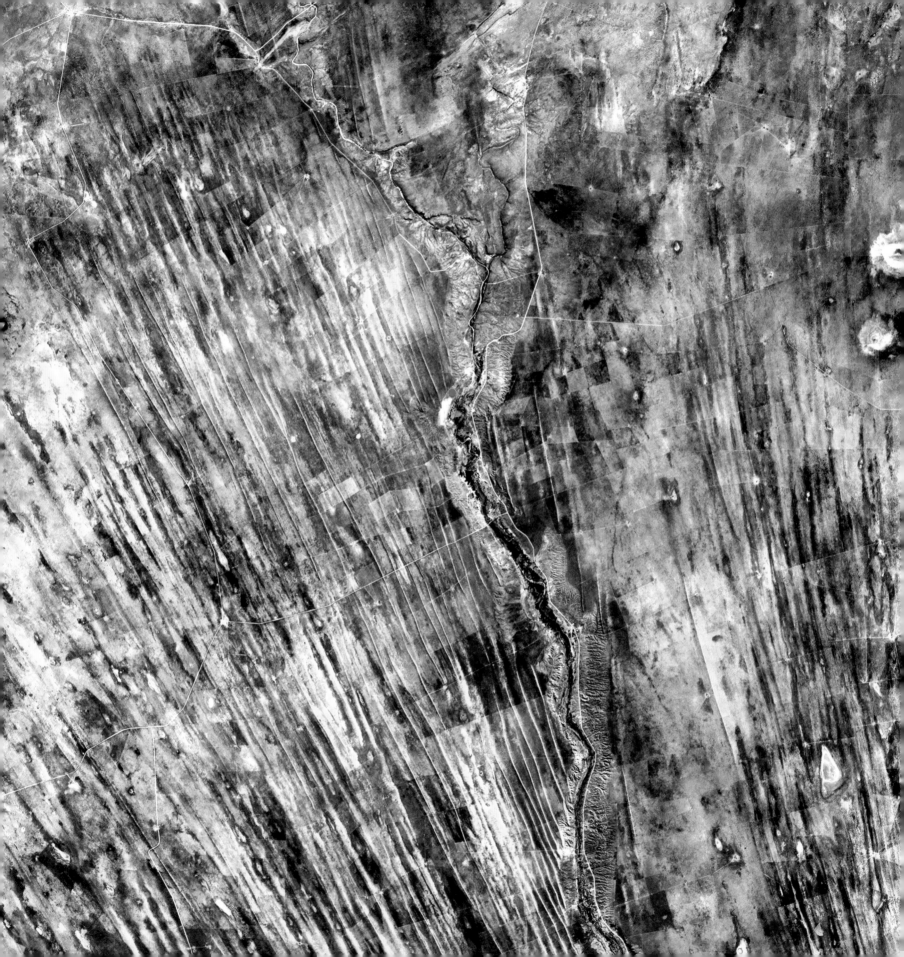

# Kamchatka Peninsula
# Russia

The eastern side of Russia's Kamchatka Peninsula juts into the Bering Sea west of Alaska. The terrain, which has been shaped by glaciers, appears covered in white snow in this 2002 winter image from Terra. Glacial cirques and moraines stand out clearly underneath the snow cover. The dark ocean is ice-free near the coast. Farther out to sea, drift ice, pack ice, and pancake ice are visible in blue and blue-gray colors.

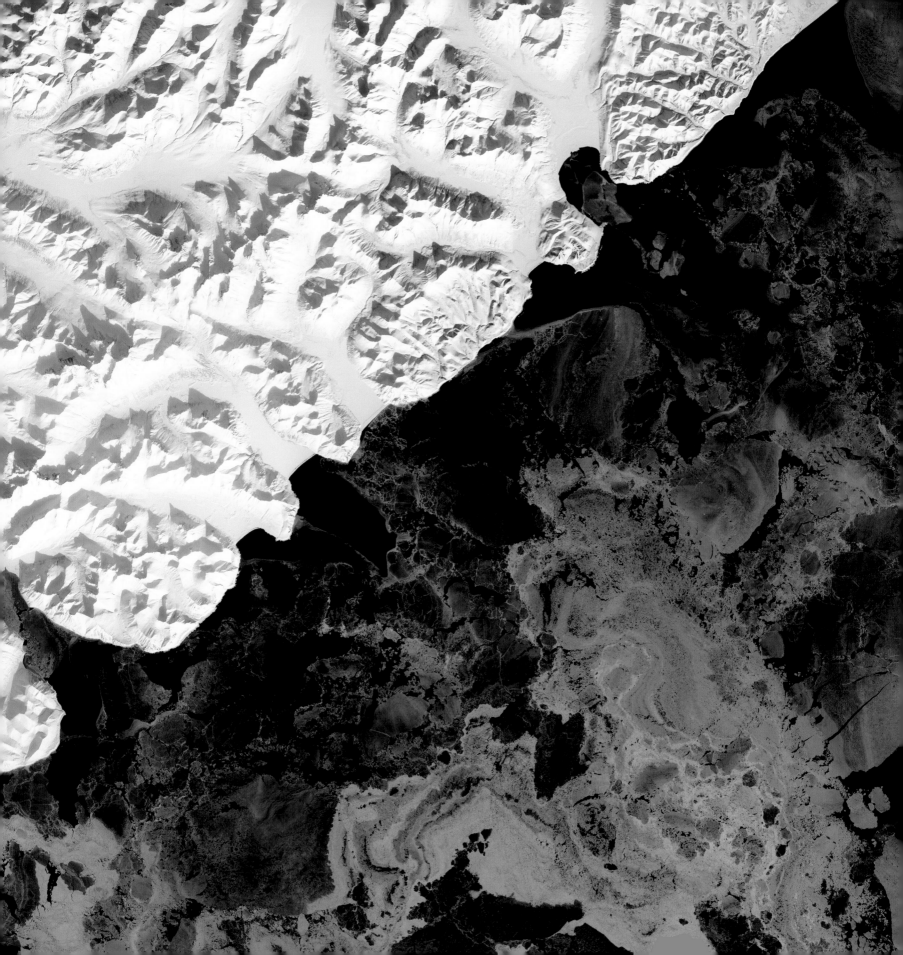

# Kilimanjaro
# Kenya and Tanzania

Landsat 7 acquired this image of portions of Kenya and Tanzania in 2000. Featured on the far right is Mount Kilimanjaro, flanked by the plains of Amboseli National Park to the north and the rugged Arusha National Park to the south and west.

Often called "The Shining Mountain," Kilimanjaro is a dormant stratovolcano. It has three volcanic cones—Kibo, Mawenzi, and Shira—and is the highest mountain in Africa. Although the mountain is located only about 300 kilometers from the equator, it has been capped by glaciers and snow for 11,000 years. This white cap shrinks and grows almost daily, and over the last century or more its overall trend has been a steady decline. The loss of Kilimanjaro's ice cover can have both climatological and hydrological implications for local populations that depend on access to meltwater from the snow and ice as a source of freshwater during dry seasons and monsoon failures.

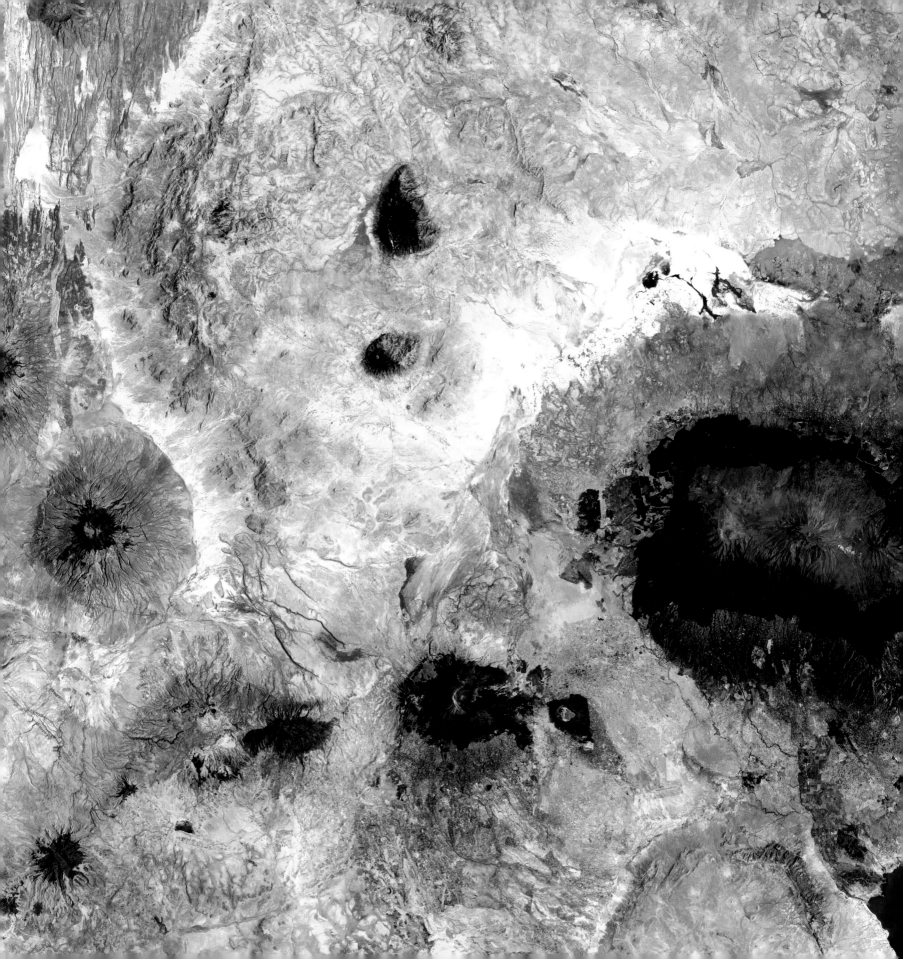

## Kuril Islands
## Sea of Okhotsk

The white swirls in this image are Kármán vortices, or fluid perturbations, that formed over the southern Kuril Islands of Broutona, Chirpoy, and Brat Chirpoyev in the Sea of Okhotsk. In this Landsat 7 image from 2000, the spiral chains and vortices are formed by the airflow being perturbed by the islands. Located in the northwest Pacific Ocean between the southern tip of Russia's Kamchatka Peninsula and the Japanese island of Hokkaido, the Kuril Islands are a part of the geological formation known as the Greater Kuril Ridge, which developed over the last 90 million years.

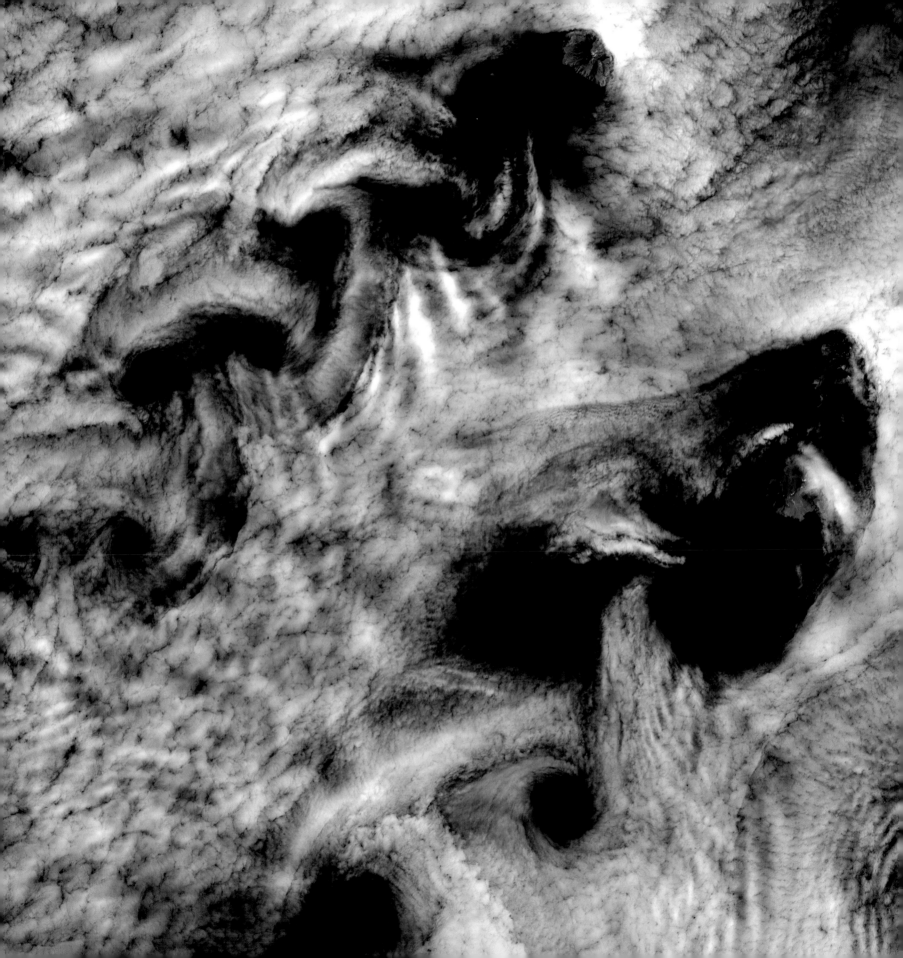

# La Rioja
# Argentina

In this 1985 Landsat 5 image, a myriad of colors denote the composition and textures of the Sierra de Velasco Mountains of northern Argentina. Pink tones and warm hues indicate the drier, more barren areas of the mountains. Ribbons of blues and greens hint at the moister areas of vegetation and heavy growth. At the base of the mountains in the lower left, a pink area marks the city of La Rioja, which is the capital city of one of the least populated and most arid provinces of Argentina. In stark contrast, the upper right of the image shows the lusher surroundings of the city of San Fernando del Valle de Catamarca and extensive vineyards.

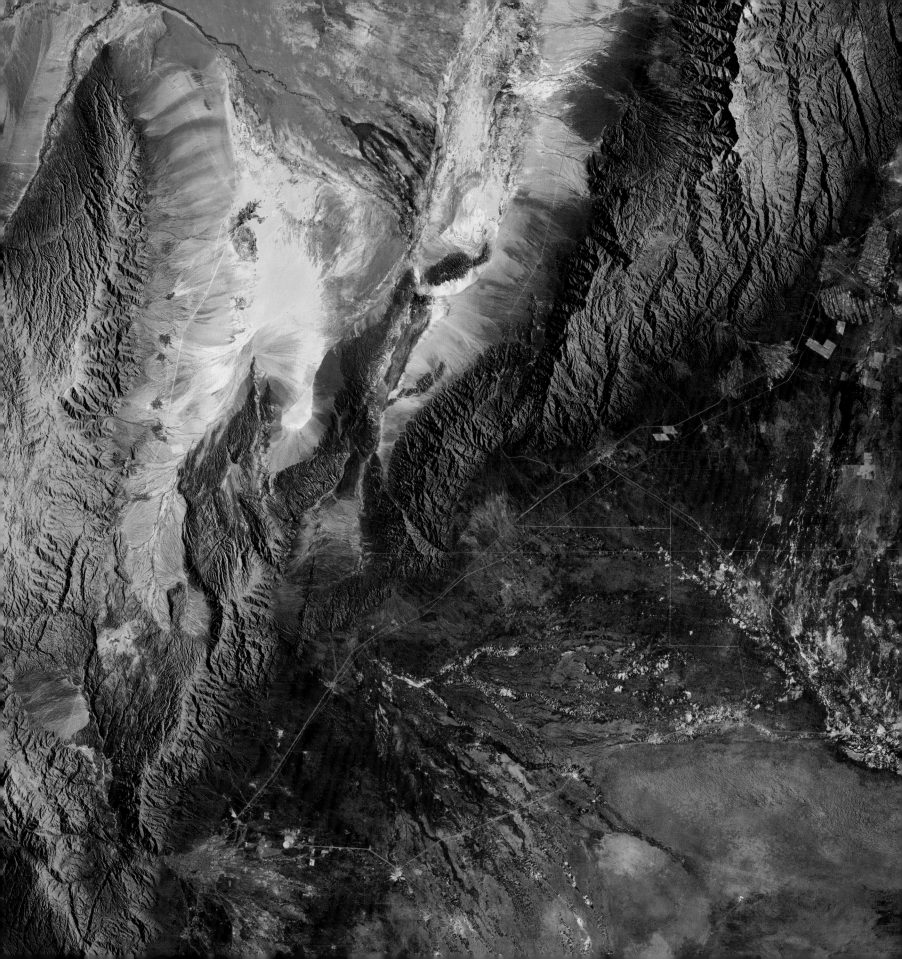

# Lake Disappointment
# Australia

Surrounded by sand dunes, Lake Disappointment is an ephemeral salt lake in one of the most remote areas of Western Australia. Located just south of Rudall River National Park, Lake Disappointment is home to many water birds. According to Aboriginal people, mythological beings are said to live in a subterranean world beneath the lake, and the lake and its surroundings are still considered taboo. In this 2000 Terra image, the gold and orange-brown areas are sand and outcrops of sedimentary rock. The dunes appear as long, linear streaks. The different colors with sharp boundaries may be traces of brush fires, with yellow being the most recent. The lake is white where bright salty deposits are visible, and blue areas are shallow water in the western part and the margins.

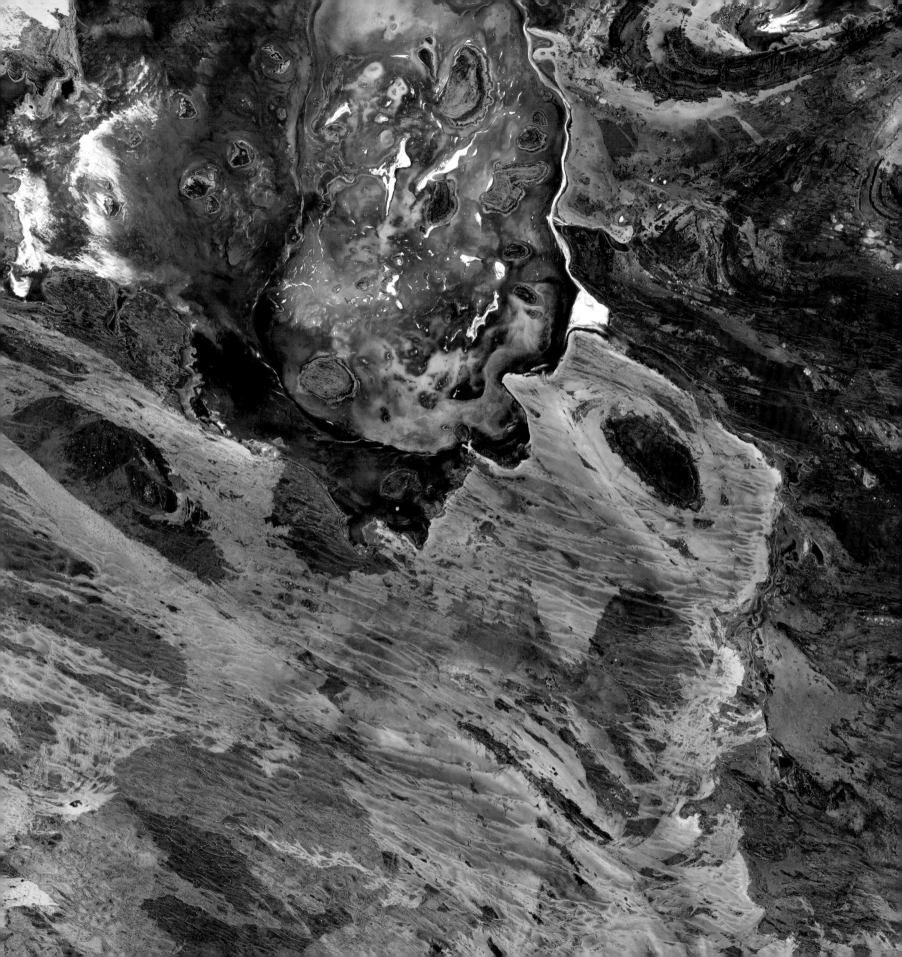

# Lake Eyre
# Australia

Deep in the desert country of northern South Australia, Lake Eyre is an ephemeral feature of this flat landscape. Lake Eyre is home to some rare ecosystems and is the largest salt pan in the world. It spans 9,300 square kilometers and sits 15 meters below sea level. The lake's basin sprawls across 1.2 million square kilometers, stretching from the Northern Territory to South Australia. Rain, when it falls, drains through the basin into Lake Eyre, which has no outlet. The lake has rarely filled completely, with spectacular fillings occurring in 1950, 1974, and 1984. When brimming, Lake Eyre is Australia's largest lake. Landsat 5 collected this image in 2006.

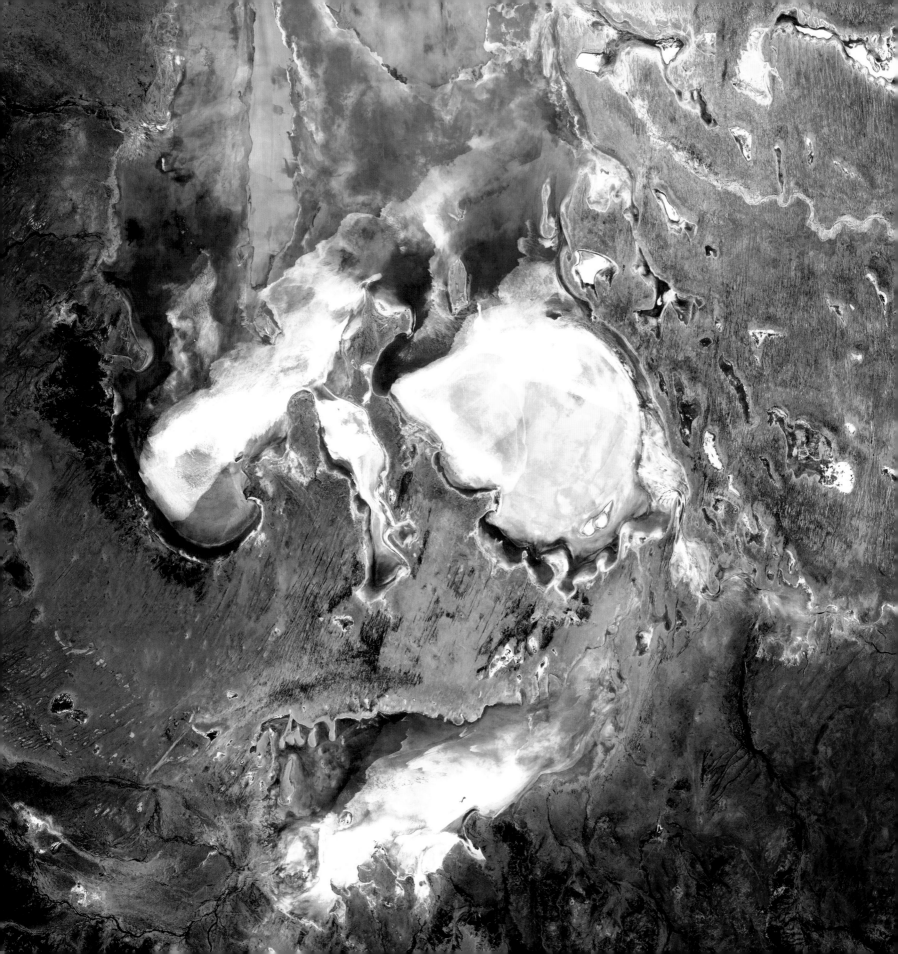

# Lena River Delta
# Russia

The Lena River Delta in Siberia extends 100 kilometers into the Laptev Sea and Arctic Ocean, and it includes an extensive protected wilderness area and wildlife refuge. In this Landsat 7 image from 2000, vegetation appears as shades of green, sandy areas as shades of red, and water as purples and blues. The Lena River Delta is about 400 kilometers wide, and it divides into a multitude of flat islands. The delta is frozen tundra for about 7 months of the year, and spring transforms the region into a lush wetland.

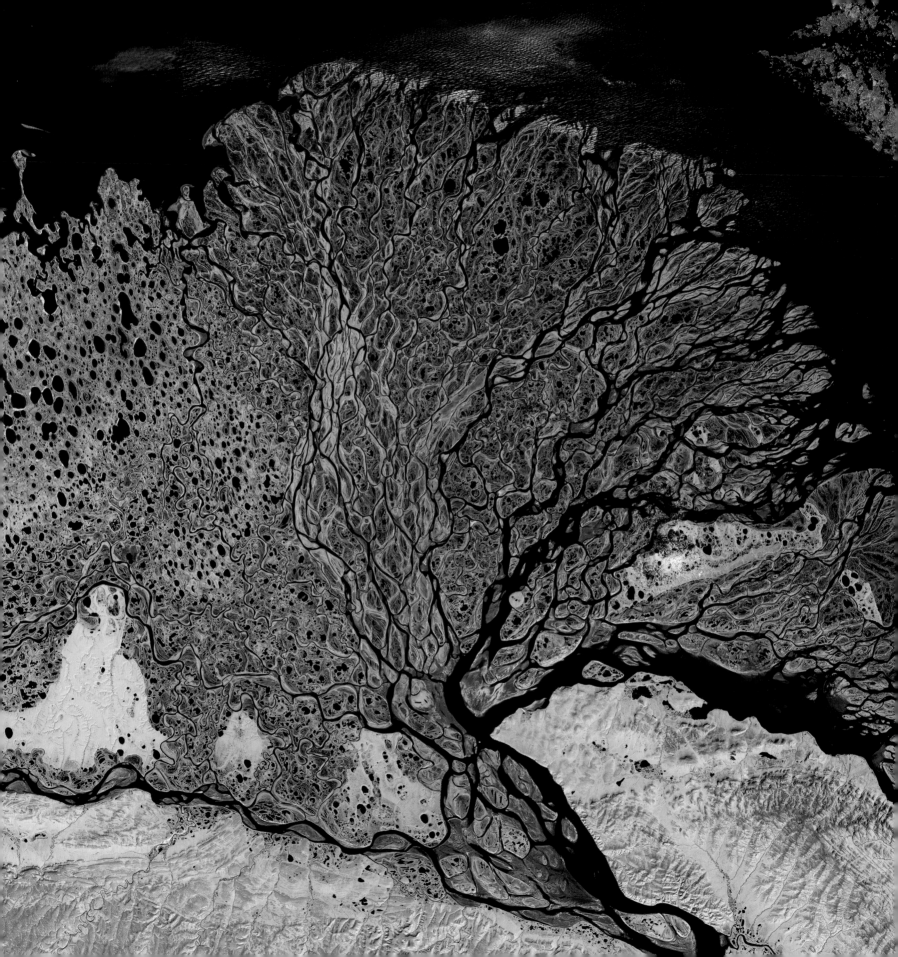

# MacDonnell Ranges
## Australia

The MacDonnell Ranges are a band of rugged mountains spanning Australia's Northern Territory. Formed 300 to 350 million years ago, the ranges have endured folding, faulting, and erosion resulting in gaps and ravines. Some of the valleys in the ranges contain fossil evidence of an inland sea that once covered central Australia. This Landsat 7 image from 2000 shows only a portion of the ranges with vegetation in green against the blues, purples, and grays of the arid surrounding area.

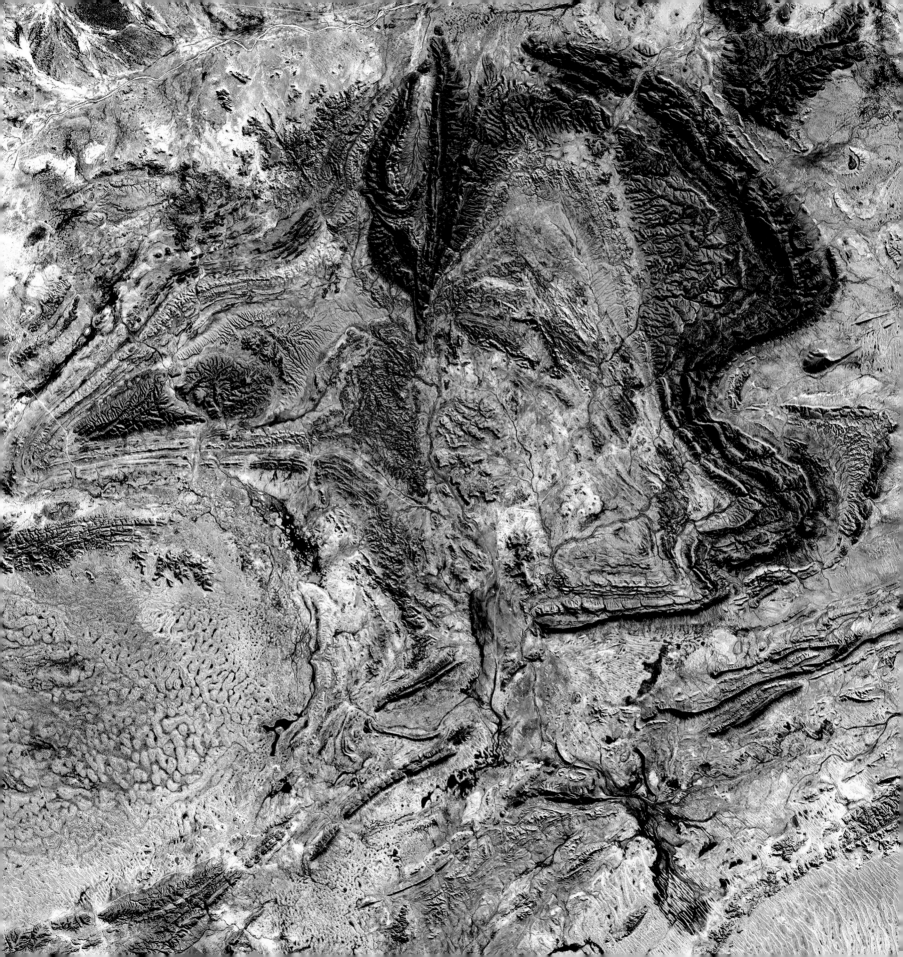

# Mayn River
# Russia

The Mayn River is featured in this 2000 Landsat 7 image with what may be a portion of the Anadyr River. The Mayn is a tributary of the Anadyr, flowing roughly northwards from its source in the Koryak Mountain Range through the far northeastern corner of Siberia and the forest-tundra subzones of the Chukotka Peninsula. While these rivers are frozen for about 8 to 9 months in a year, they are home to chum and sockeye salmon during the summer months.

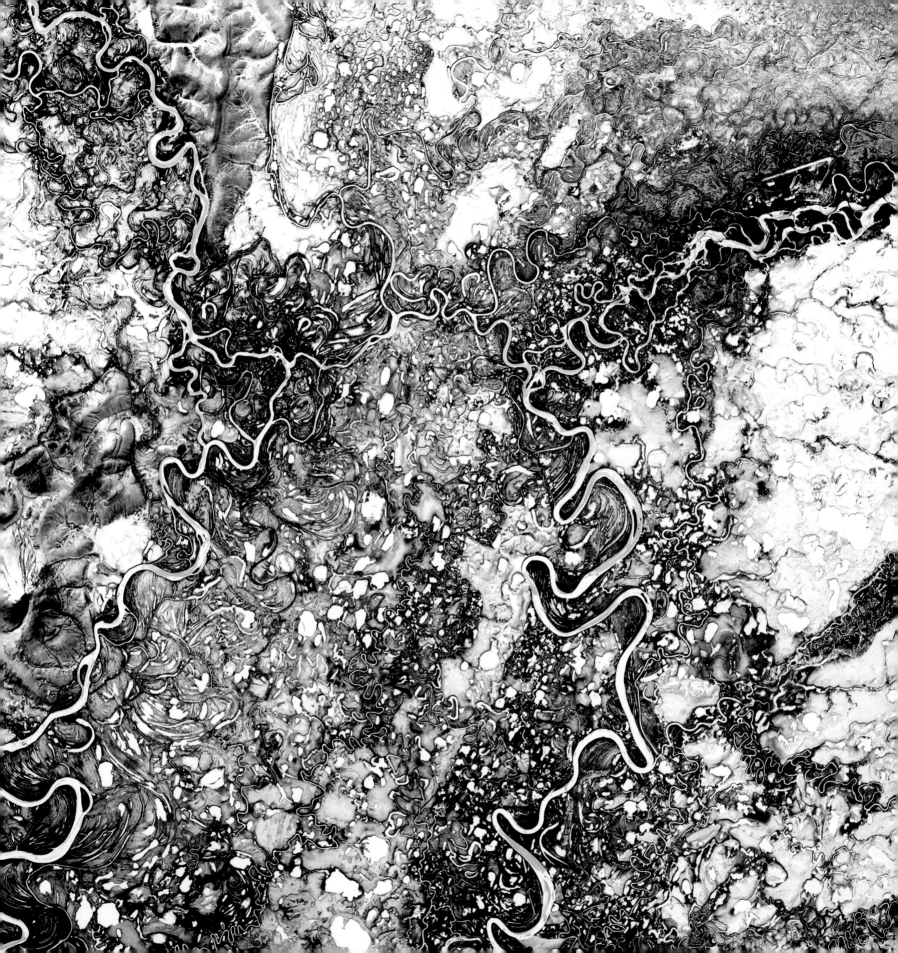

# Meandering Mississippi
# United States

Graceful swirls and whorls of the Mississippi River encircle fields and pastures in this Landsat 7 image from 2003. Oxbow lakes and cutoffs accompany the meandering river south of Memphis, Tennessee, on the border between Arkansas and Mississippi. The mighty Mississippi is the largest river system in North America and forms the second largest watershed in the world.

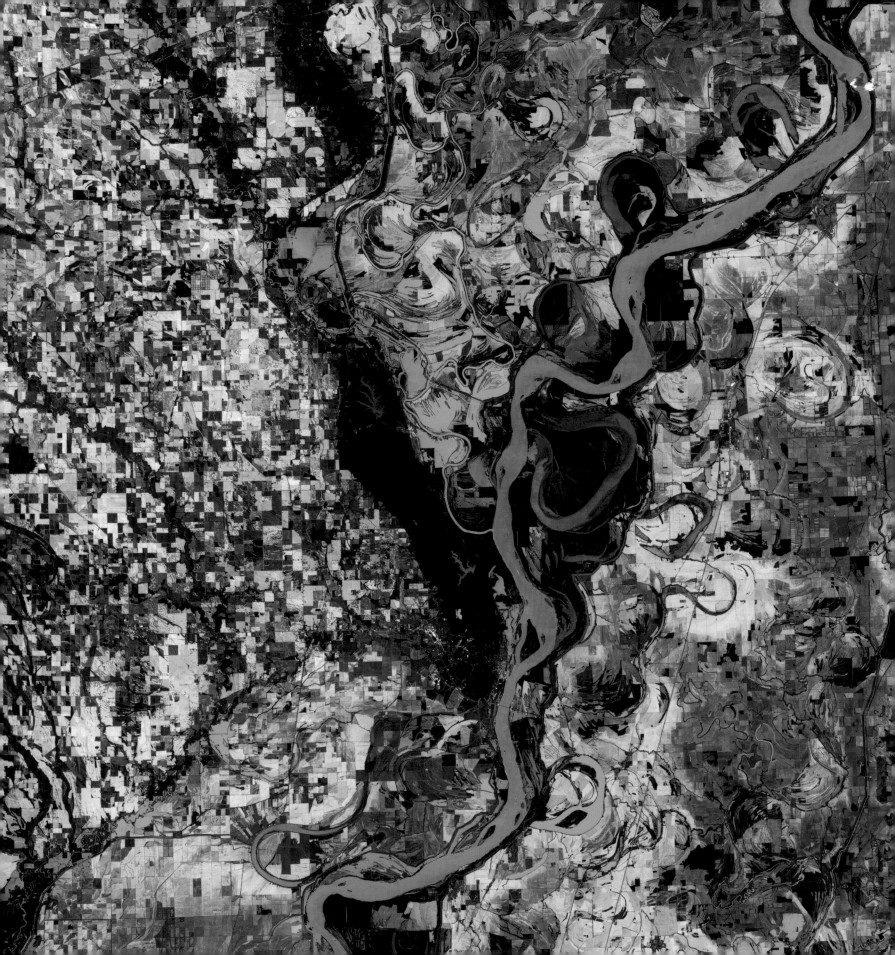

## Mississippi River Delta
## United States

After receiving the Arkansas and Red Rivers, the Mississippi River travels to its terminus and joins the Gulf of Mexico. The river's turbid waters spill out into the Gulf of Mexico, and its suspended sediment is deposited to form the Mississippi River Delta. As seen in this 2001 Terra image, marshes and mudflats (shades of green) prevail between shipping channels cut into the bird's-foot delta. The marshes protect the mainland from storm surges and provide a home for fish and wildlife.

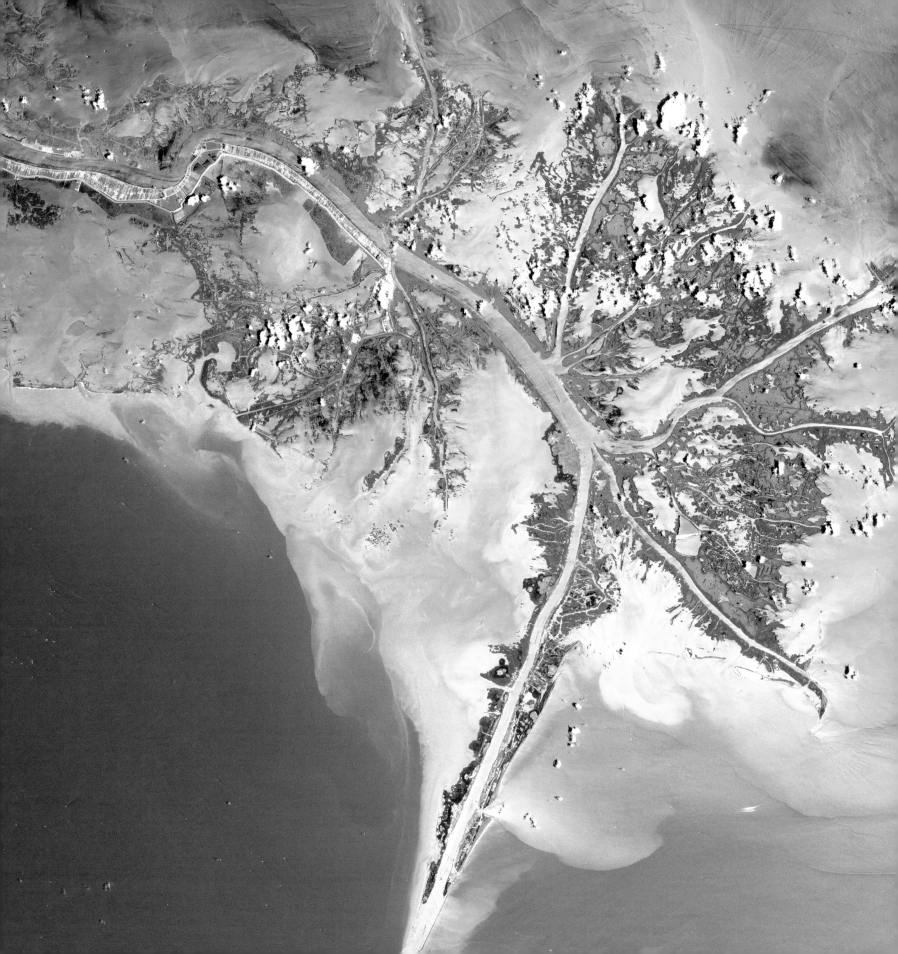

# Mount Elgon
# Kenya and Uganda

Clouds dot the high rim of Mount Elgon's massive caldera in this Landsat 5 image from 1984. As the oldest and largest solitary volcano in Africa, Mount Elgon straddles the border between Uganda and Kenya and is protected on both sides by national parks. Named Ol Doinyo Ilgoon by the Maasai, this long-extinct volcano has an intact caldera about 6,500 meters across and consists of five major peaks over a distance of 4,100 meters. In the image, the lush green that surrounds the volcano shows the fertility of the rich volcanic soil at the lower elevations. The upper left corner shows one of the arms of the large shallow lake complex of Lake Kyoga.

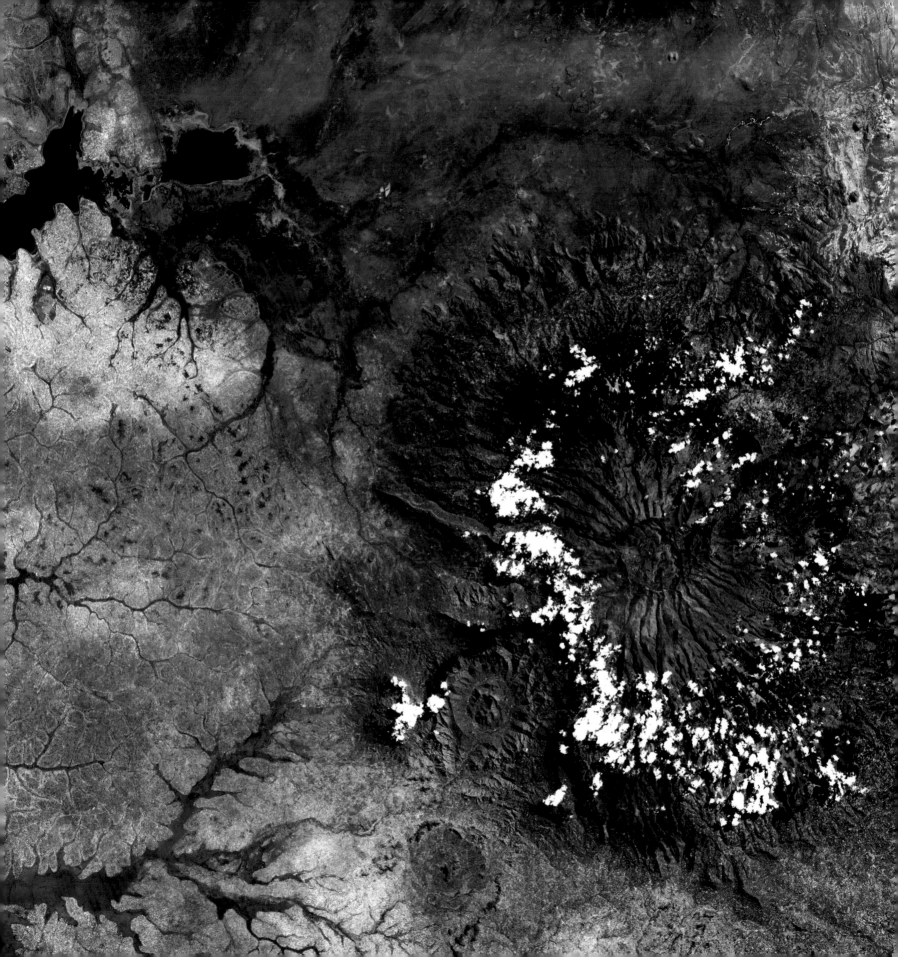

## Musandam Peninsula
## Oman

Rocky and rugged, the Musandam Peninsula juts into the Strait of Hormuz, the narrow entry into the Persian Gulf. Musandam is an exclave of Oman, separated from the rest of the country by the United Arab Emirates. This Terra image acquired in 2004 shows the tip of the peninsula.

The peninsula's distinctive fjord-like physiography is due to submergence of the land as the Arabian Plate slowly pushes under the Eurasian Plate. The peninsula forms the southern part of the Strait of Hormuz. The Persian Gulf is to the west, Iran is across the strait, and the Gulf of Oman is to the east-southeast.

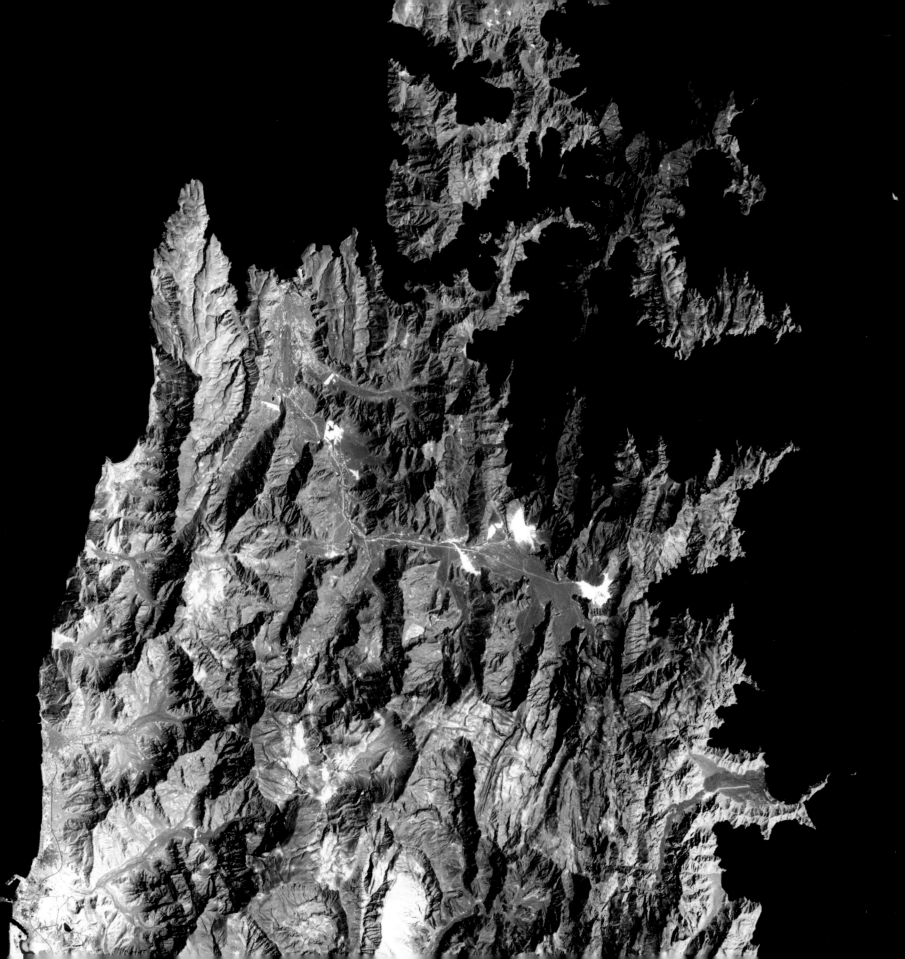

# Namib Desert
# Namibia

The Namib-Naukluft National Park is an ecological preserve and includes Namibia's vast Namib Desert. Here, southwest winds have created the tallest sand dunes in the world, with some dunes reaching 300 meters in height. The park hosts a collection of animals that manage to survive in this hyper-arid region, including oryx, hyenas, jackals, and springbok. In the center of this 2000 Landsat 7 image, giant dunes line up along the edge of Sossus Vlei, a clay pan at the end point of the Tsauchab River. While the river now flows 30 kilometers into the Namib Sand Sea before ending at Sossus Vlei, it may have once extended much farther west through the desert, with the dunes gradually invading as river flooding declined.

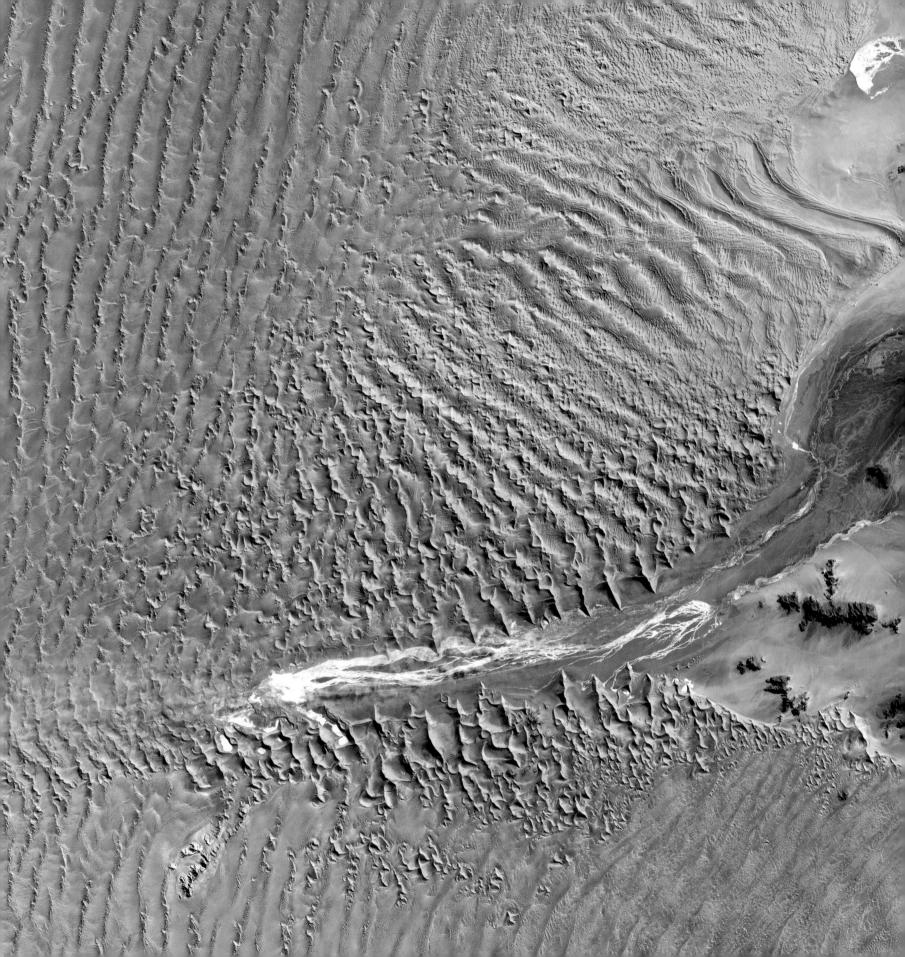

# Nazca Lines
# Peru

The Nazca Lines are a series of ancient geoglyphs located in the Ica Region in southern Peru. Estimated to be created by the Nazca culture between 400 and 650 C.E., the Nazca Lines were made by removing reddish iron-oxide pebbles that cover the surface of the desert. When the gravel is removed, the lines contrast with the light color underneath. In this 2000 Terra image, the straight Nazca Lines differ sharply from the natural, wavy lines formed from water flow in the area. Overall, there are hundreds of individual figures, which range in complexity from simple lines to stylized hummingbirds, spiders, monkeys, fish, sharks, orcas, llamas, and lizards. The Nazca Lines were designated a UNESCO World Heritage Site in 1994.

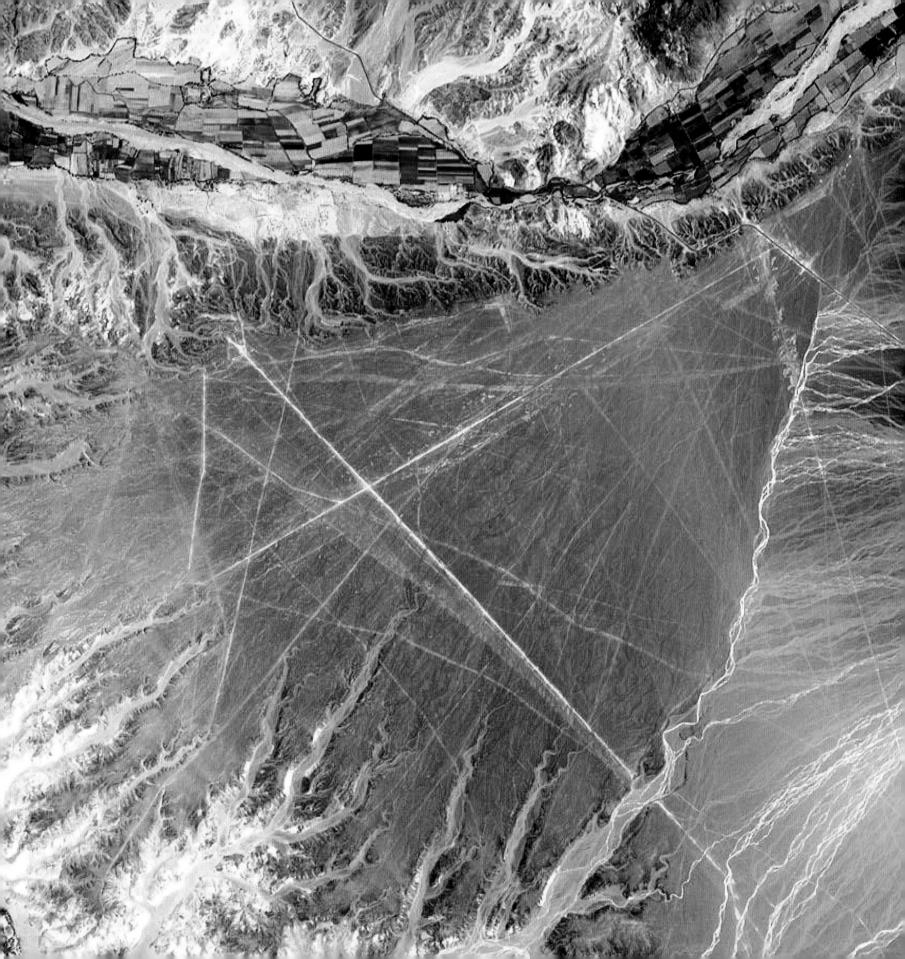

# Niger River
# Mali

The Niger River and smaller rivers and streams flow northward out of Lake Debo in landlocked Mali in Western Africa. This region is part of the Inner Niger Delta, an intricate combination of lakes, river channels, and swamps with occasional areas of higher elevation. Known as the Macina, this wet oasis in the African Sahel is one of the largest wetlands in the world and provides habitat both for migrating birds and for West African manatees. The fertile floodplains also provide much-needed resources for the local people, who use the area for fishing, grazing livestock, and cultivating rice. This Terra image from 2003 shows the region during the dry season. On the right, water in rivers, streams, and lakes appears blue. On the left, the water turns greener, perhaps because of sediment. The reddish ridges running from east to west in the bottom half of the image are dunes. The pale-gray or white areas between the dunes are flat areas of silt, clay, or sandy soil. Blue shows where water has filled in between some of the dunes.

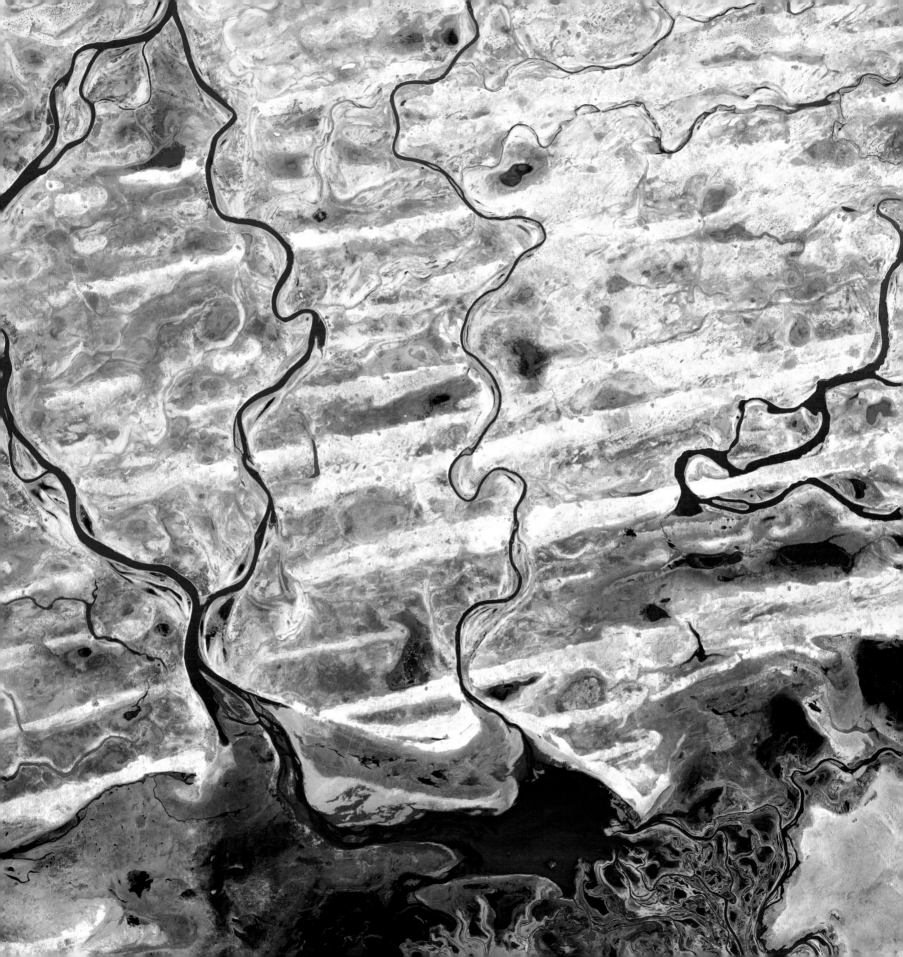

# Okavango Delta
# Botswana

Southern Africa's Okavango River spreads across the landscape of northern Botswana to become the lush Okavango Delta seen in this Landsat 5 image from 2009. The Okavango Delta is one of the world's largest inland water systems, draining an area that ranges from 9,000 square kilometers (May–October) to 16,000 square kilometers (November–April). Millions of years ago, the Okavango River flowed into a large inland lake called Lake Makgadikgadi. Today, the delta forms where the river empties into a basin in the Kalahari Desert, creating a maze of lagoons, channels, and islands. This unique water system supports a vast array of wildlife, and vegetation flourishes even in the dry season.

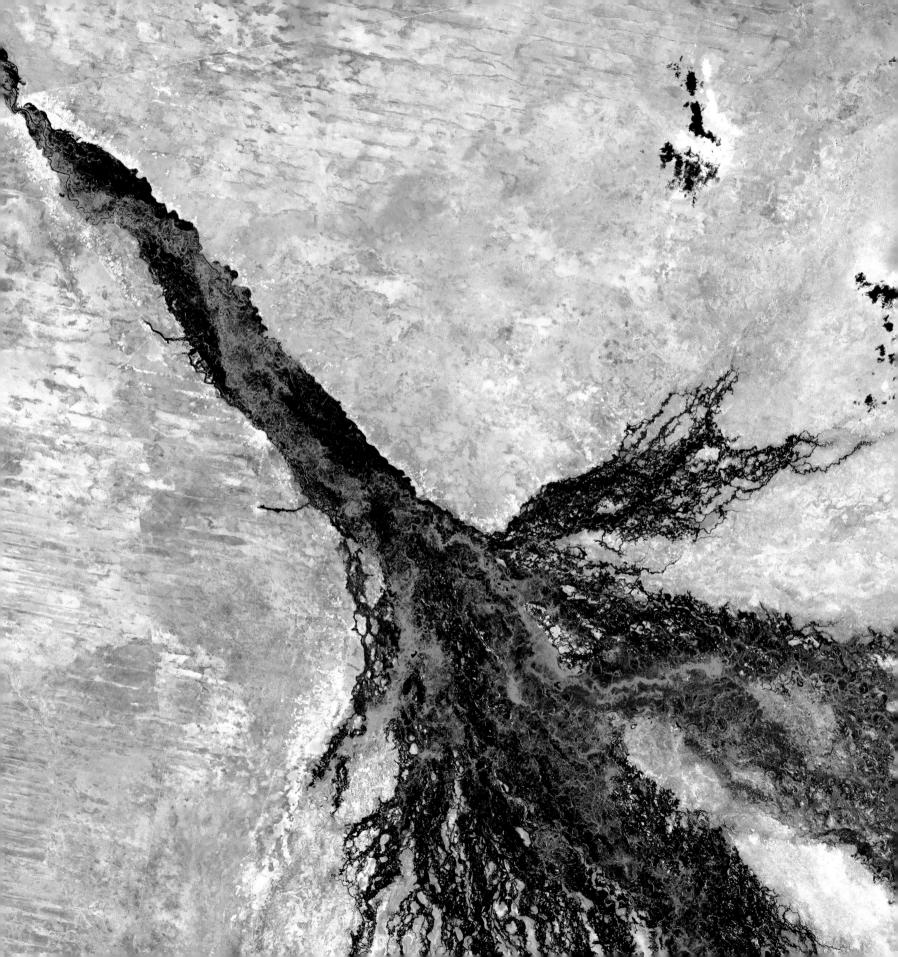

## Painted Desert
## United States

In Arizona there lies a long expanse of arid, erosion-prone, austere badlands made of multicolored mudstones and clays. This "Painted Desert" extends from the Grand Canyon southeast to the Petrified Forest National Park, stretching over 260 kilometers and encompassing over 36,000 hectares. This 2009 Landsat 5 image captured the Painted Desert as it abruptly ends at the Sitgreaves National Forest, an area with thousands of hectares of forest as well as eight cold-water lakes. Also within the Painted Desert lie the Hopi Buttes, a field of ancient volcanic cones, seen here as a scattering of dark, circular shapes near the top of the image.

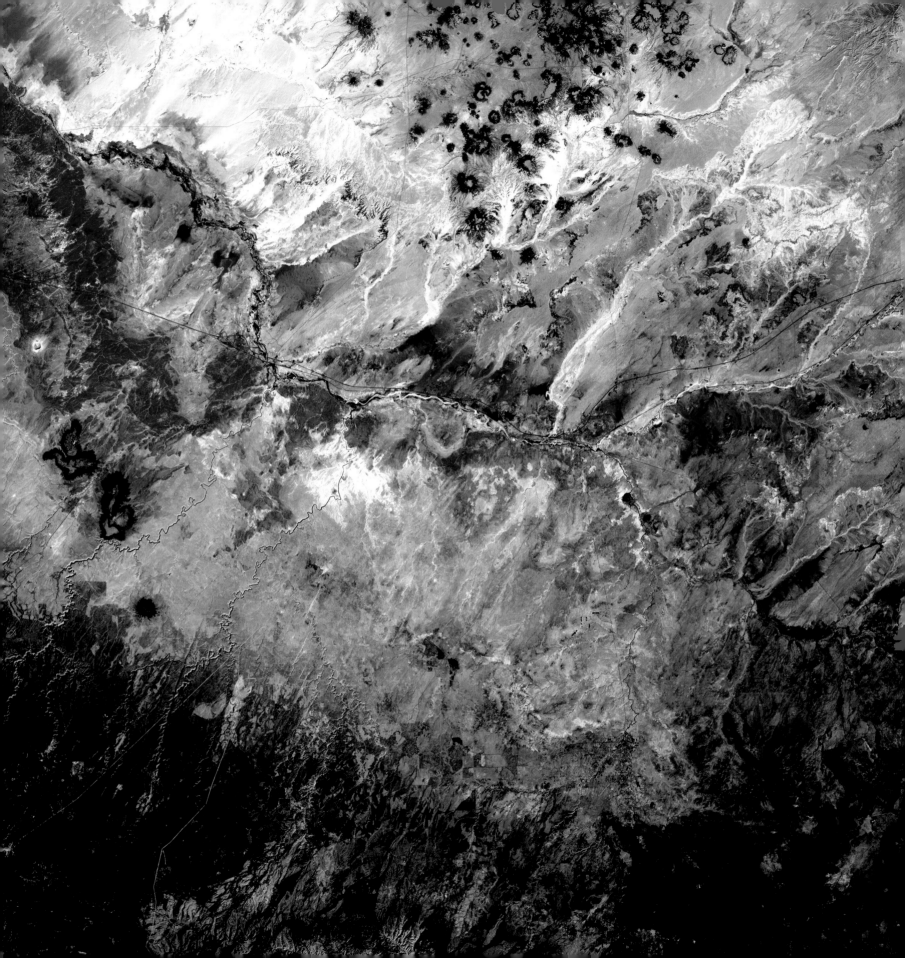

# Paraná River Delta
# Argentina

The Paraná River delta is a forested marshland about 32 kilometers northeast of Buenos Aires and has a vast labyrinth of marsh and trees. The delta is home to a number of rare birds and has become a popular bird-watching destination. It is also home to marsh deer, jaguars, neotropical river otters, coypu and capybara rodents, and the Pampas cat. The Paraná flows north-south and forms an alluvial basin before it empties into the Río de la Plata. This Landsat 7 image from 2000 highlights the striking contrast between dense forest, wetland marshes, and the deep blue ribbon of the Paraná River.

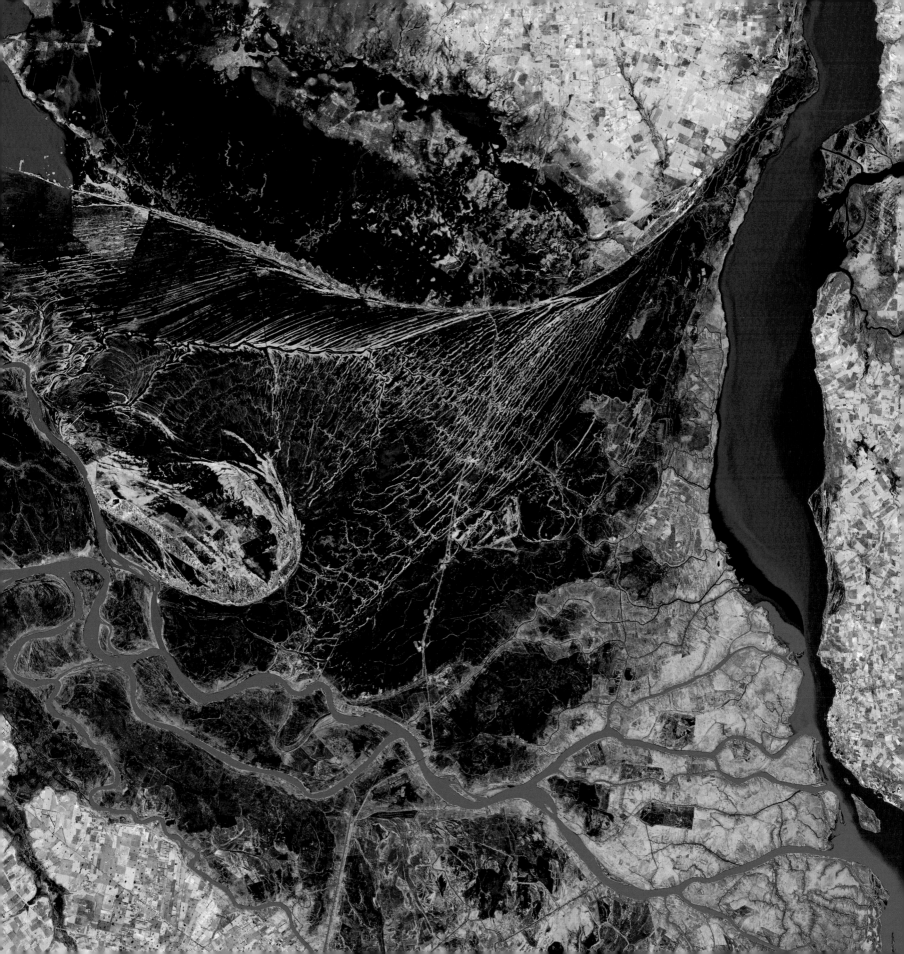

## Phytoplankton Bloom
## Baltic Sea

In this Landsat 7 image from 2005, massive congregations of greenish phytoplankton swirl in the dark water around Gotland, a Swedish island in the Baltic Sea. Phytoplankton are microscopic marine plants that form the first link in nearly all ocean food chains. Population explosions, or blooms, of phytoplankton, like the one shown here, occur when deep currents bring nutrients up to sunlit surface waters, fueling the growth and reproduction of these tiny, photosynthesizing organisms.

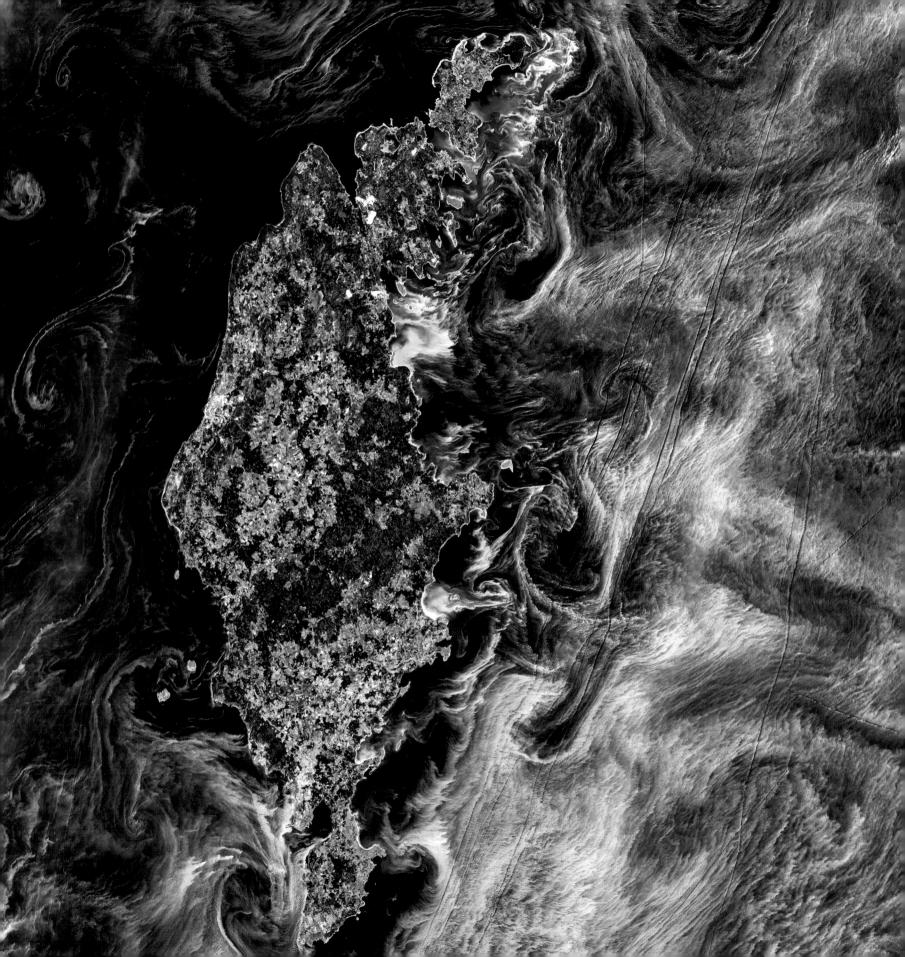

## Pinacate Volcano Field
## Mexico

The pockmarked terrain of Pinacate National Park in Mexico's state of Sonora is evidence of a violent past. Among hundreds of volcanic vents and cinder cones are rare maar craters, formed when rising magma met underground water to create pockets of steam that blew nearly circular holes in the overlying crust. At the bottom of this 2002 Landsat 7 image are sand dunes of the Gran Desierto de Altar in the Sonoran Desert, including the only active erg dune region in North America. During the 1960s, NASA sent astronauts to the Pinacate area to train for lunar expeditions.

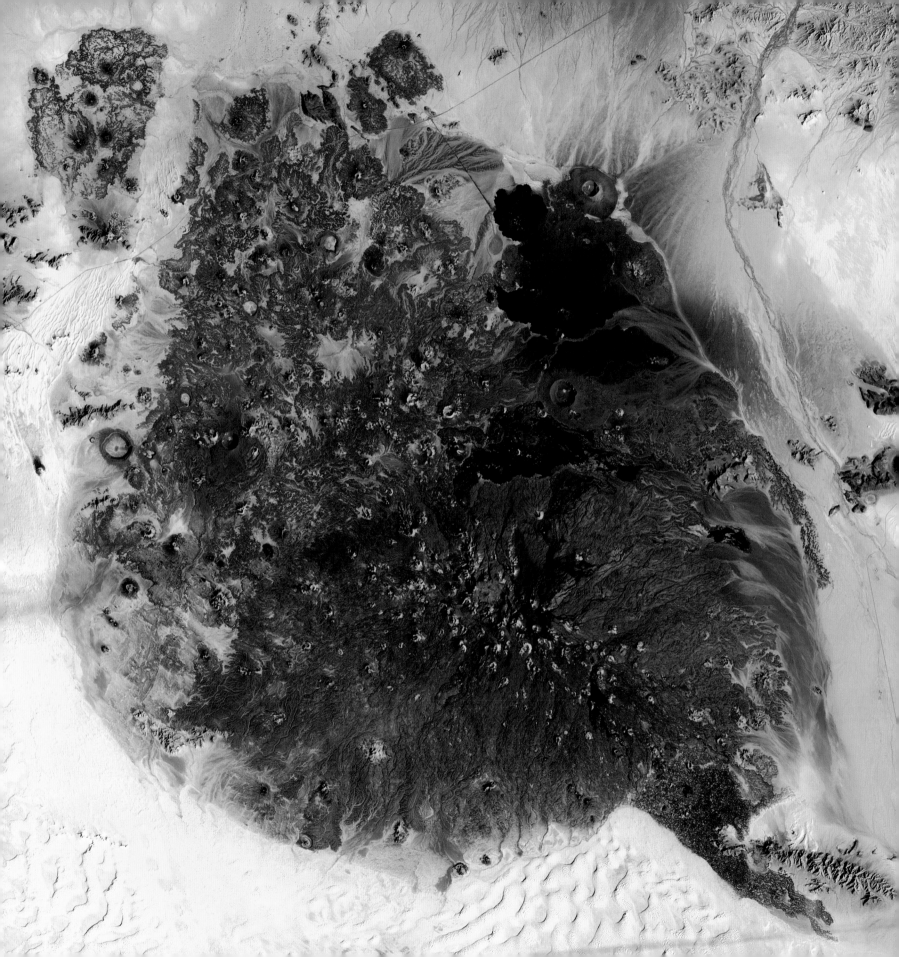

## Ribbon Lakes
## Russia

The vivid blue half circle (bottom) in this Landsat 5 image from 2005 is Russia's Chaunskaya Bay in northeastern Siberia. Two major rivers, the Chaun and Palyavaam, flow into the bay, which in turn opens into the Arctic Ocean. Ribbon lakes and bogs are present throughout the area, created by depressions left by receding glaciers. Owing to its extreme northern location, the bay is covered by ice most of the year.

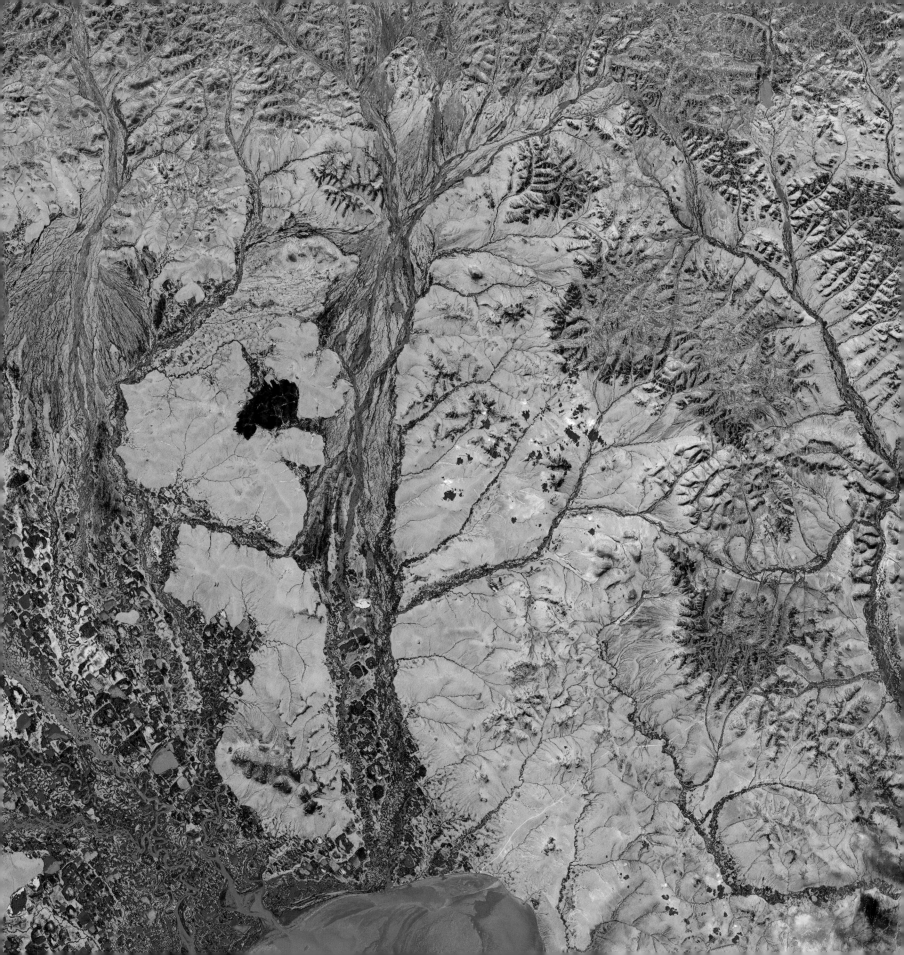

# Richat Structure
# Mauritania

Viewed from space, the Richat Structure forms a conspicuous 50-kilometer-wide bull's-eye on the Maur Adrar Desert in the African country of Mauritania. Described by some as looking like an outsized fossil, the feature has become a landmark for astronauts. Although it resembles an impact crater, the structure formed when a volcanic dome hardened and gradually eroded, exposing the onion-like layers of rock. In this 2001 Landsat 7 image, desert sands appear white and pale yellow at the top left and lower right corners of the scene. Less sandy, rocky areas are green, and volcanic rocks are blue.

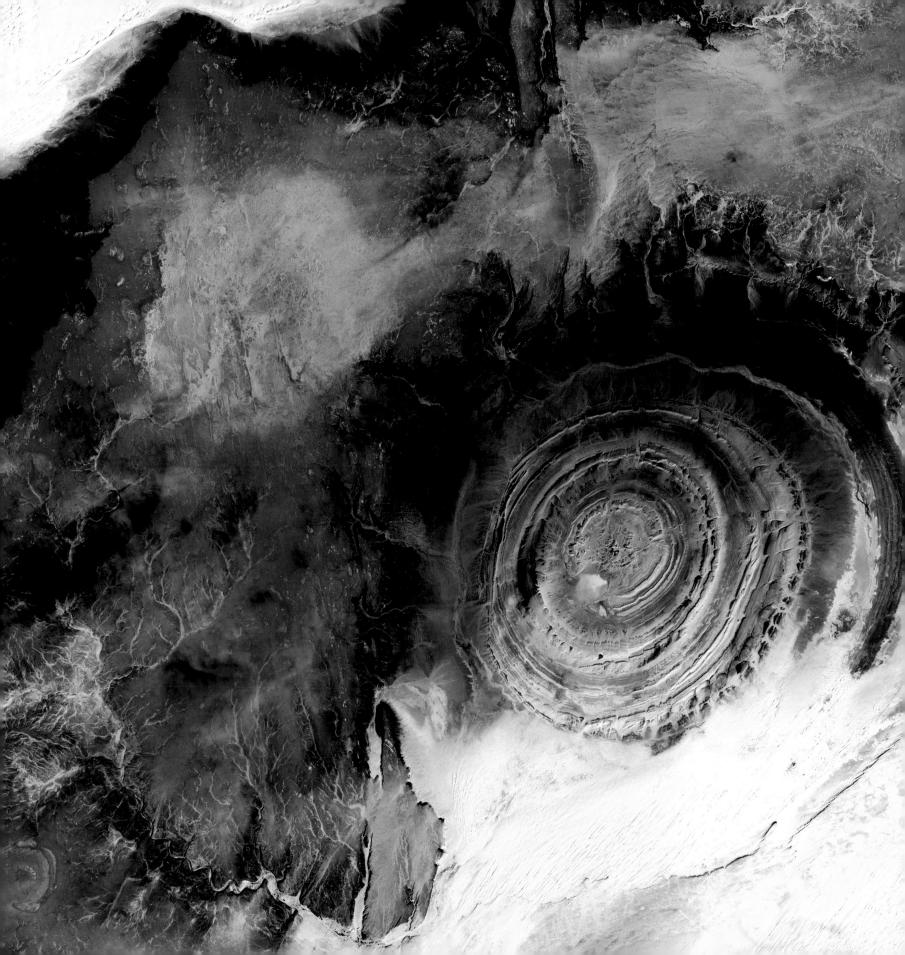

## Rocky Mountain Trench
## Canada

The stroke of red in this 2004 Landsat 5 image is a remarkable interplay of light and cloud in the Canadian Rockies. The Rocky Mountain Trench is a valley that stretches from the U.S. state of Montana to just south of Canada's Yukon Territory. It runs parallel with the peaks of the Canadian Rockies, ranging from 3 to 16 kilometers wide. Low clouds filled a part of the Trench near the border between the Canadian provinces of Alberta and British Columbia. The light-reflecting nature of the clouds coupled with low Sun elevation resulted in this startling effect. The Trench aligns with the Fraser River and makes its way past Mount Robson, the highest peak in the Canadian Rockies. Mount Robson is near the center of this image.

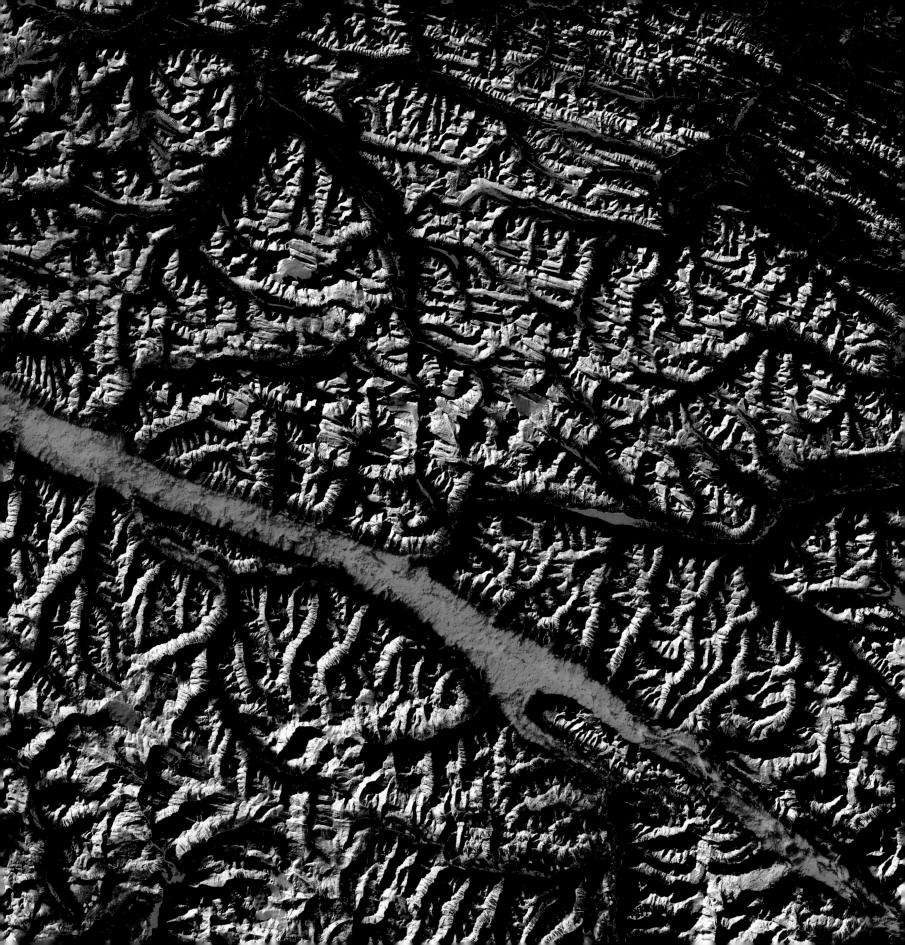

# Rub' al Khali
# Arabian Peninsula

The Rub' al Khali, or Empty Quarter, is one of the largest sand deserts in the world, covering 650,000 square kilometers and encompassing most of the southern third of the Arabian Peninsula. The desert includes much of Saudi Arabia and parts of Oman, the United Arab Emirates, and Yemen. Landsat 7 collected this image in 2001.

With daytime temperatures reaching 50 degrees Celsius and dunes taller than 330 meters, the desert may be one of the most forbidding places on Earth today. However, there is evidence of ancient lakes and wildlife. Fossils of cattle and hippos are abundant, as are flint weapons and tools. Additionally, space-based measurements uncovered evidence of ancient civilizations. Subsequent excavations uncovered a large, octagonal fortress and shards of Greek, Roman, and Syrian pottery.

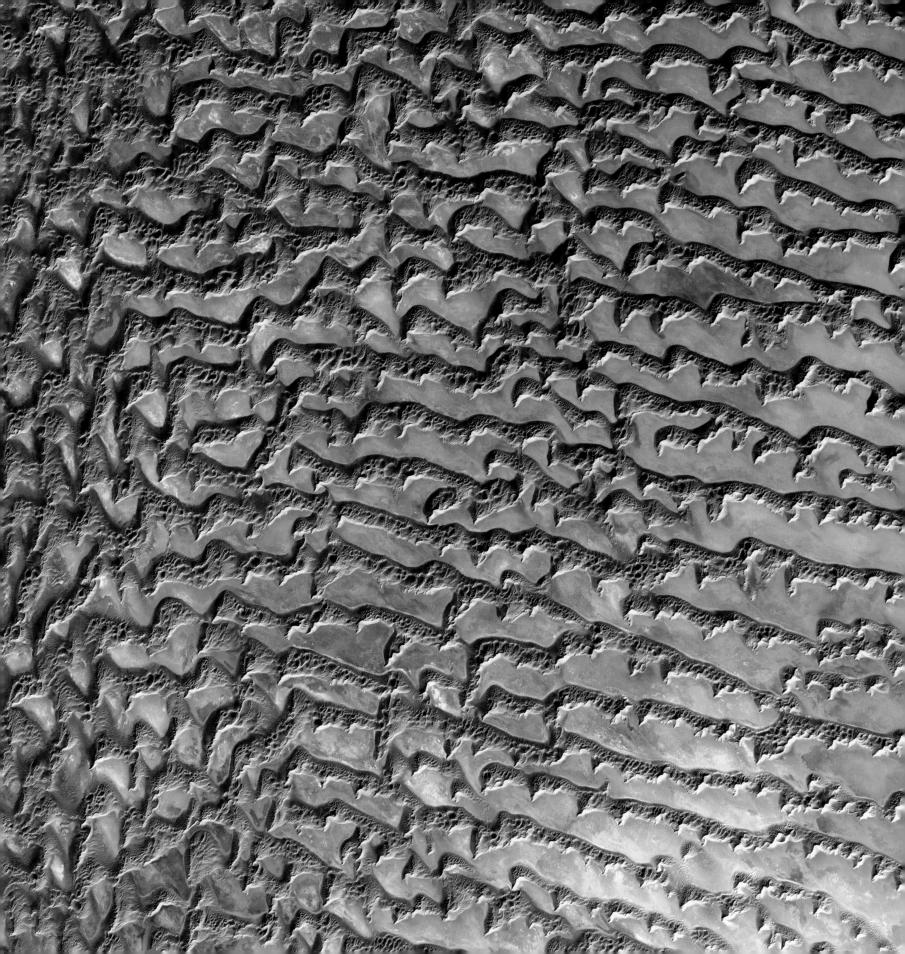

# Sand Hills
# United States

As the largest sand dune formation in America, the Sand Hills cover about a quarter of the U.S. state of Nebraska. These ancient sand dunes are from the Pleistocene Epoch (1.8 million to about 10,000 years ago). They are made of sediment eroded from the Rocky Mountains by glaciers, washed out into the plains, and now mostly stabilized by grassland vegetation. This 2001 Terra image shows a portion of the Sand Hills region, the landscape rippled by crowded yellow-tan and lavender-brown dunes. The area does not drain water well, so the hollows at the bases of dunes are filled with brilliantly blue lakes.

The sandy soils were not attractive to farmers, and the area was left largely unplowed by European settlers. Today, the area is being cultivated as seen in some of the emerald green vegetation in the image. Perfect circles of vegetation resulting from center-pivot irrigation appear in the scene, as well as fields with sharp angles and straight lines. The area is an important habitat for migratory birds.

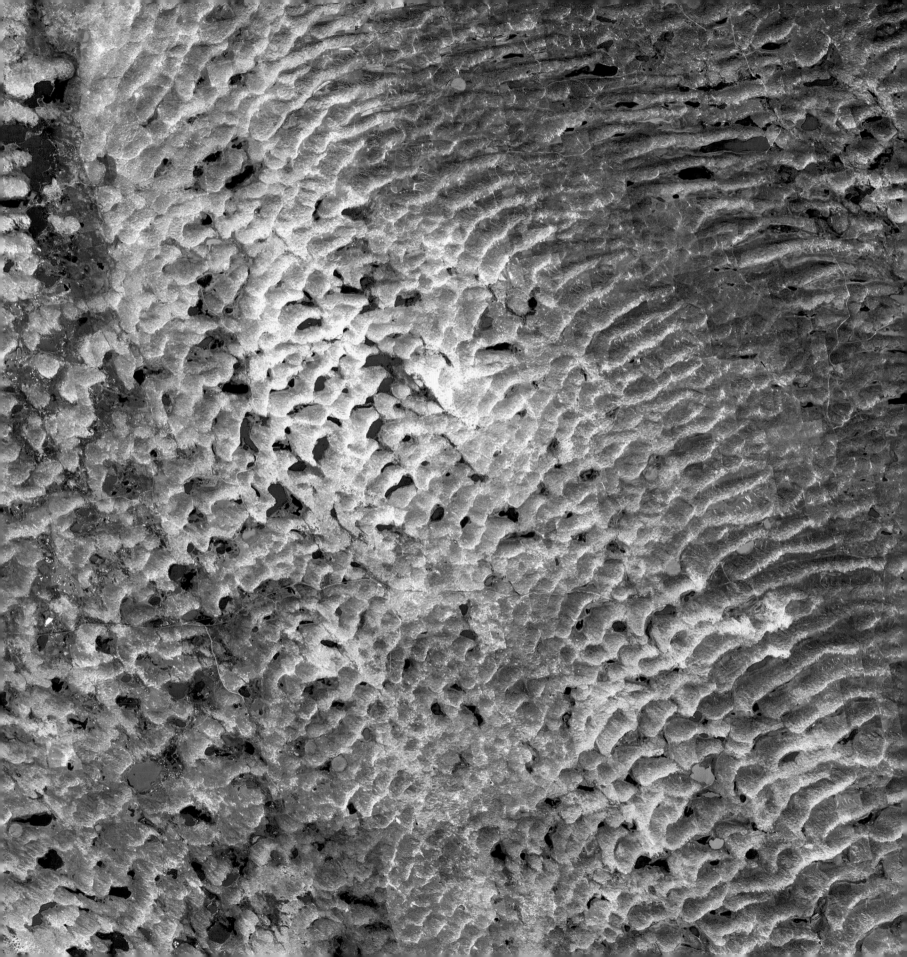

# Shoemaker Crater
# Australia

Salt-encrusted seasonal lakes, seen here in yellow and green, dot the floor of Western Australia's Shoemaker impact structure, the deeply eroded remnant of a former impact crater. The structure is named in honor of planetary geologist Eugene Shoemaker and is situated in arid central Western Australia, about 100 kilometers north-northeast of the town of Wiluna. The structure was formed about 1.7 billion years ago and is currently the oldest known impact site in Australia. Landsat 7 collected this image in 2000.

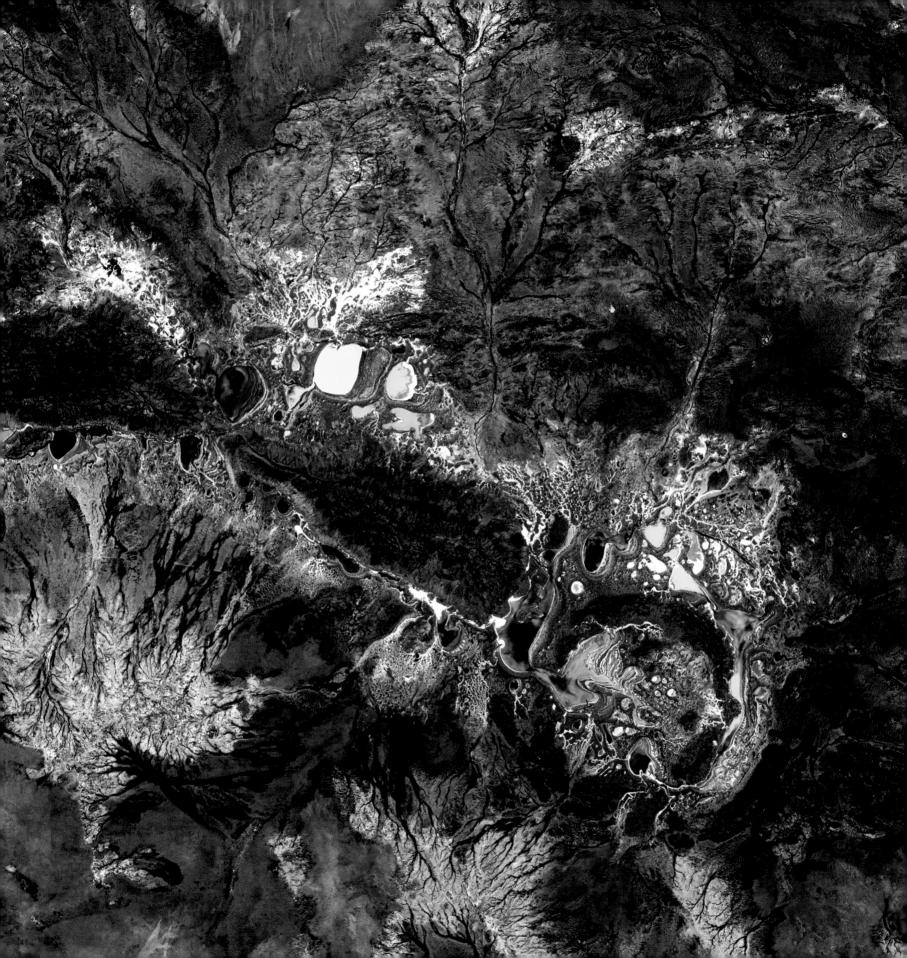

# Sierra Madre Oriental
# Mexico

Mexico's chief mountain system consists of the Sierra Madre Oriental, the Sierra Madre Occidental, and the Sierra Madre del Sur—all named with a variation of Sierra Madre, a Spanish phrase meaning Mother Highlands. The rugged Sierra Madres extend from northwest to southeast through Mexico and have deep, steep-sided barrancas (canyons). Landsat 7 acquired this image in 1999, and it depicts a desolate area of the Sierra Madre Oriental range on the border between the Mexican states of Coahuila and Nuevo León.

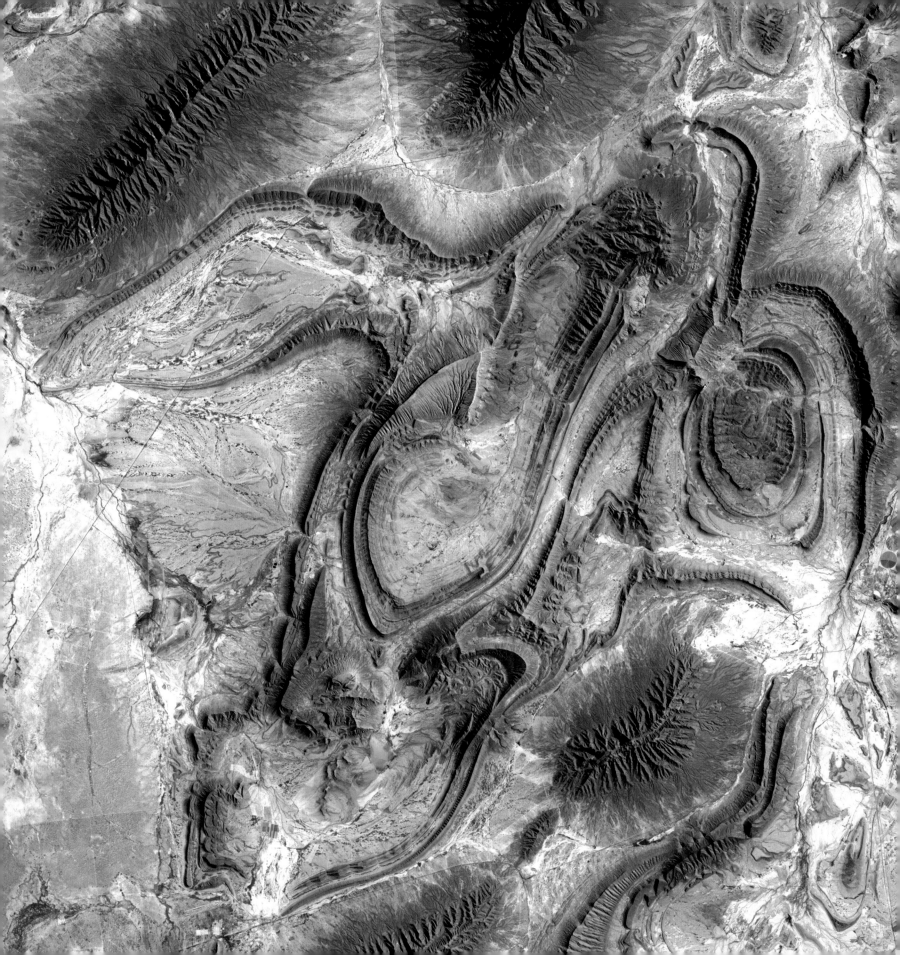

# South Georgia Island
# South Atlantic Ocean

Located in the South Atlantic Ocean due east of Argentina's southernmost tip, South Georgia Island is entirely covered by snow and ice in this Terra image from 2002. The island is some 170 kilometers long, with a rugged terrain and 11 mountain peaks more than 2,000 meters high. Many boundary layer cumulus clouds fill the atmosphere surrounding the island. The sinewy patterns snaking across the cloud bank (upper left corner) indicate open-cell convection. The island appears to be creating a wake of thicker marine stratocumulus clouds flowing away from its northeast shore. All around the island, phytoplankton appear to be in bloom, giving the deep-blue South Atlantic waters a lighter, more turquoise hue. Sir Ernest Shackleton stopped on South Georgia Island twice, once in 1914 and again in 1915, as part of the Imperial Trans-Antarctic Expedition he led on the ship *Endurance*. With no permanent human inhabitants, South Georgia Island is now a wildlife sanctuary and home to seals, reindeer, and sea and land birds.

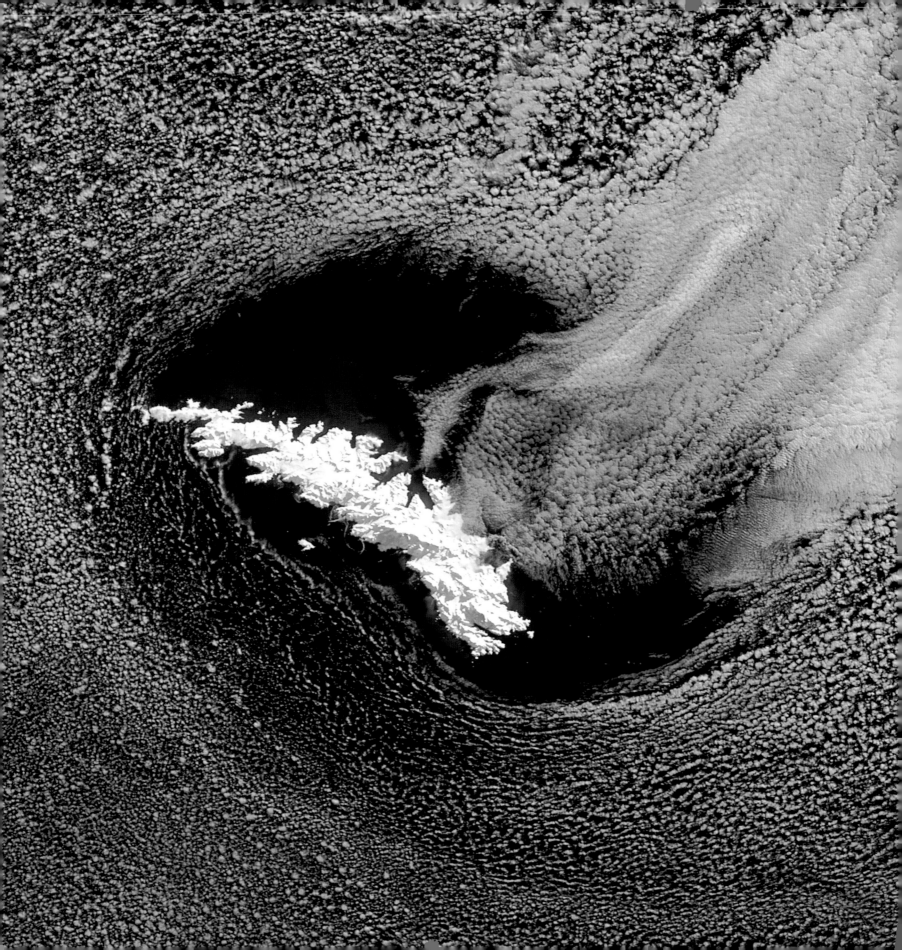

# Southern Sahara Desert
# Africa

What appear as soft shades of blue and blond are actually one of the harshest landscapes on Earth. This glimpse of Africa's Sahara Desert, located near where the borders of Mali, Niger, and Algeria converge, is truly a no-man's-land—a world of sand and rock without roads or settlements. The horizontal lines across the top half of the image are intrusions of igneous rock, where magma has emerged from deep underground. Landsat 5 acquired this image in 2009.

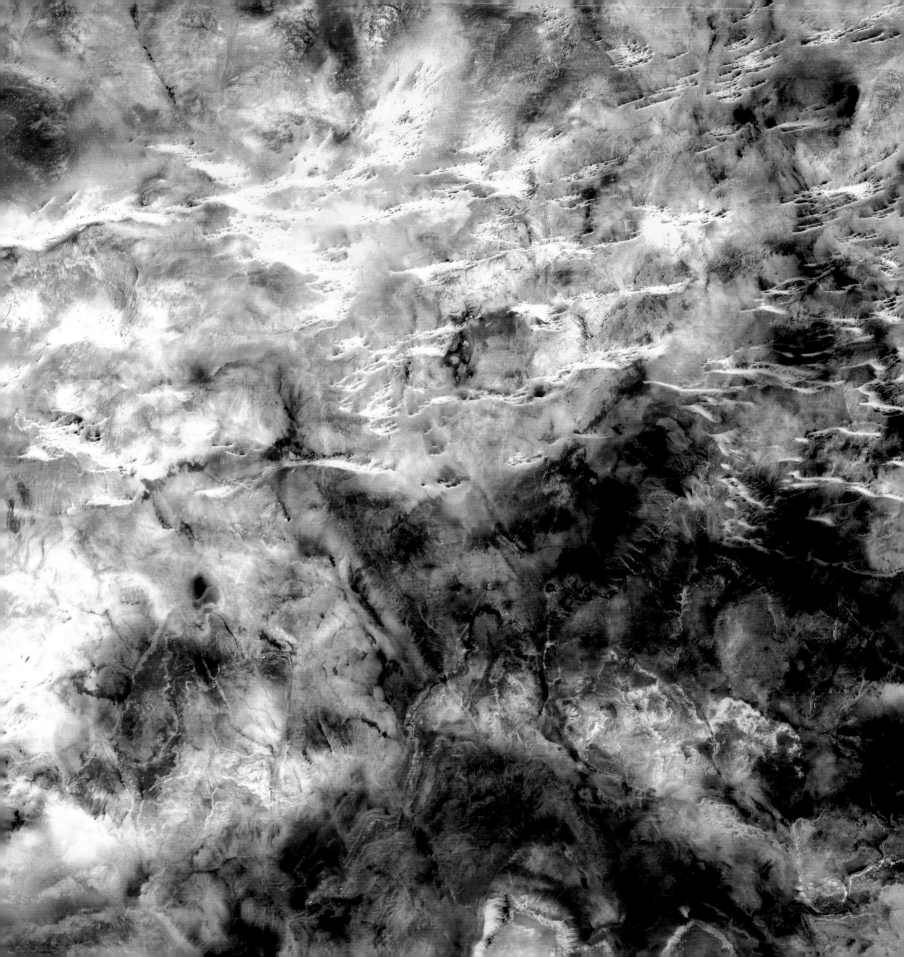

## Susitna Glacier
## United States

Folds in the lower reaches of valley glaciers can be caused by powerful surges of tributary ice streams. Susitna Glacier in the Alaska Range, seen in this Terra image from 2009, displays this phenomenon. Vegetation appears in shades of red and snow is white. The glacier's surface is marbled with dirt-free blue ice and debris-coated brown ice. Infusions of relatively clean ice push in from tributaries in the north. The glacier surface appears especially complex near the center of the image, where a tributary has pushed the ice in the main glacier slightly southward.

Steep cliffs and slopes exist in the glacier surface, with most of the jumble the result of surges in tributary glaciers. Glacial surges can occur when meltwater accumulates at the base of a tributary and lubricates the flow. The underlying bedrock can also contribute to glacier surges, with soft, easily deformed rock leading to more frequent surges.

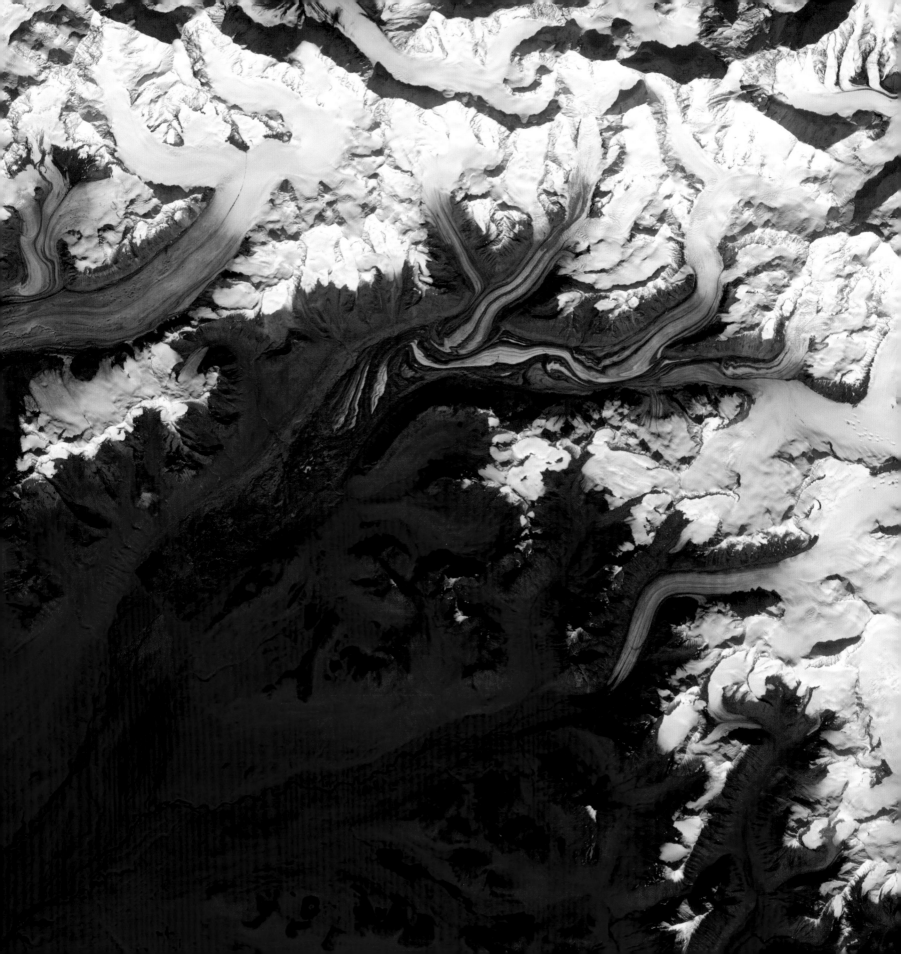

# Syrian Desert
# West Asia

Between the cultivated lands along the eastern Mediterranean Sea and the fertile Euphrates River lies the Syrian Desert, covering parts of modern Syria, Jordan, Saudi Arabia, and Iraq. This Landsat 7 scene from 2000 centers on the southern end of the Syrian Desert's As-Safa lava fields southeast of the city of Damascus. The image captures the hottest terrain in bright red, and these areas likely correspond to dark, barren, basaltic lava. Cooler terrain is bluish green, while pockets of lush vegetation in oases and towns are bright green. Cinder cones pockmark the northern fields, while bright blue pools of water appear throughout.

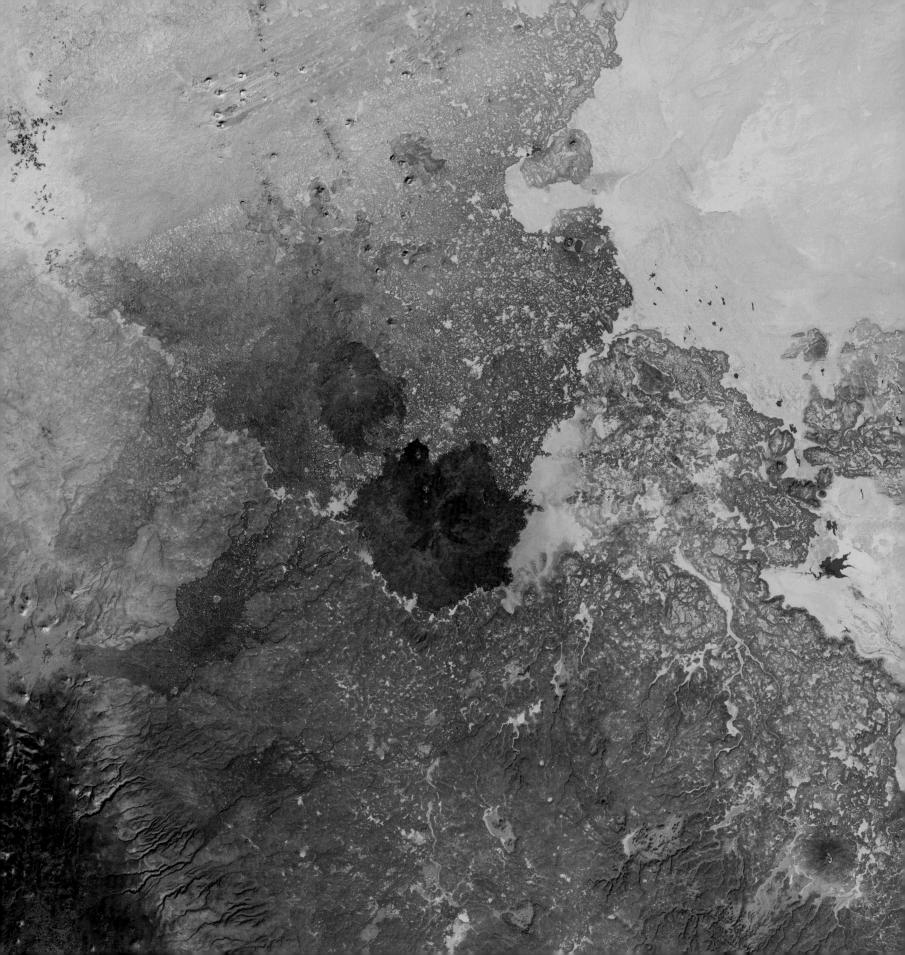

# Tassili n'Ajjer
# Algeria

Meaning "Plateau of the Rivers" in Berber, Tassili n'Ajjer is a mountain range and vast plateau in southeast Algeria near the border of Libya and Niger. Part of the Sahara Desert, the area has a bone-dry climate with scant rainfall yet does not blend in with Saharan dunes. Instead, the rocky plateau rises above the surrounding sand seas, covering an area of 72,000 square kilometers. Made from multiple Landsat 7 observations from 2000, the image highlights the area's various rock types. Sand appears in shades of yellow and tan, granite rocks appear brick red, and blue areas are likely salts.

Over billions of years, alternating wet and dry climates have shaped these rocks in multiple ways. Deep ravines are cut into cliff faces along the plateau's northern margin. The ravines are remnants of ancient rivers that once flowed off the plateau into nearby lakes. Where those lakes once rippled, winds now sculpt the dunes of giant sand seas. In drier periods, winds eroded the sandstones of the plateau into "stone forests" and natural rock arches.

Humans have also modified the park's rocks. Some 15,000 engravings have so far been identified in Tassili n'Ajjer. From about 10,000 B.C.E. to the first few centuries C.E., successive populations also left the remains of homes and burial mounds. Rich in geologic and human history, Tassili n'Ajjer is an UNESCO Biosphere Reserve and World Heritage Site.

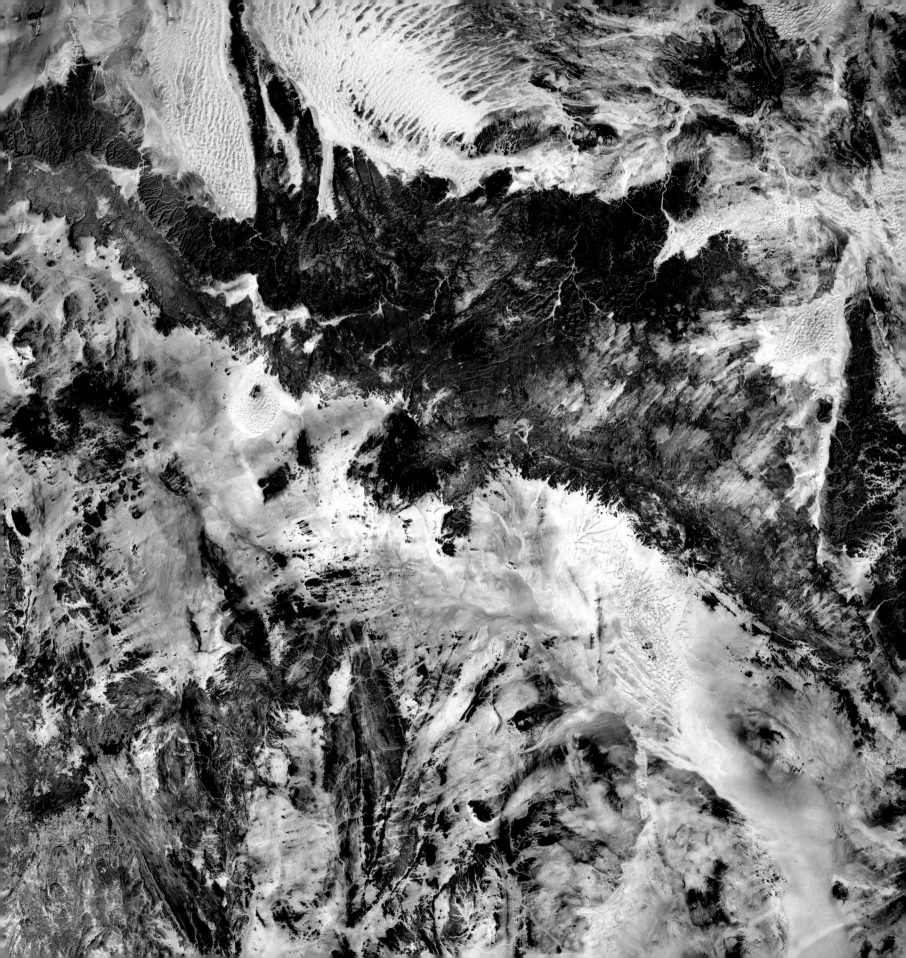

# Terkezi Oasis
# Chad

A series of rocky outcroppings emerge from a blanket of sand in this 2000 Landsat 7 image of the Sahara Desert near the Terkezi Oasis in the country of Chad. As Earth's largest band of dry land, the Sahara dominates the northern third of Africa. Stretching across this immense desert are vast plains of sand and gravel; seas of sand dunes; and barren, rocky mountains. Only 10,000 years ago, grasses covered the region and mammals such as lions and elephants roamed the land. Now only 2 percent of the Sahara hosts oases, patches of land usually centered on natural water springs where crops will grow and people live.

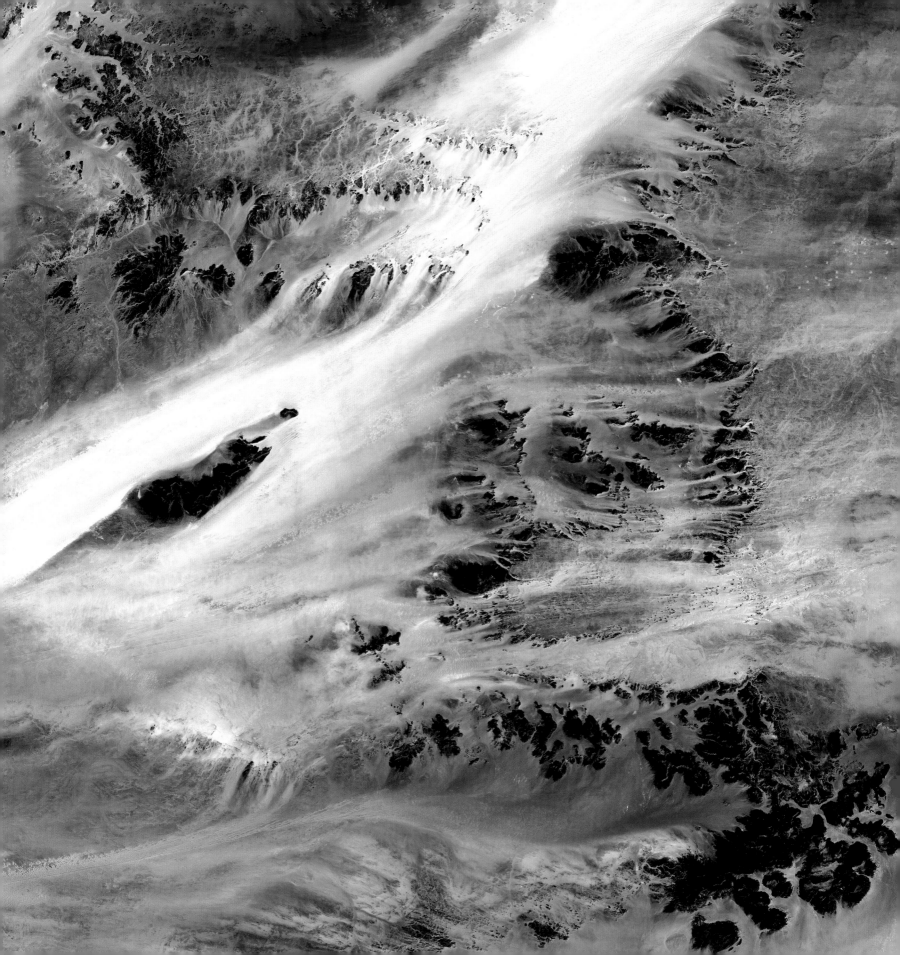

# Three Massifs
# Sahara Desert

Three large rock massifs appear to be pushing up from beneath red sand dunes in this 2000 Terra image. The Tassili n'Ajjer massif is on the left, the Tadrart Acacus is in the middle, and the Tadrart Amsak is on the right. The image includes the southern part of the border between Algeria and Libya, and different rock types account for varying colors. The Tadrart Acacus massif contains some unique scenery and natural wonders, including colored sand dunes and isolated towers that eroded into bizarre shapes and petrified arches.

The dendritic structures of ancient riverbeds are visible in the Acacus-Amsak region. This area is believed to have been wet during the last glacial era, covered by forests and populated by wild animals. Archaeologists have found indications of animal domestication and large numbers of rock paintings and engravings, faint tracks of ancient civilizations. Extremely dry weather conditions today help to preserve their masterpieces.

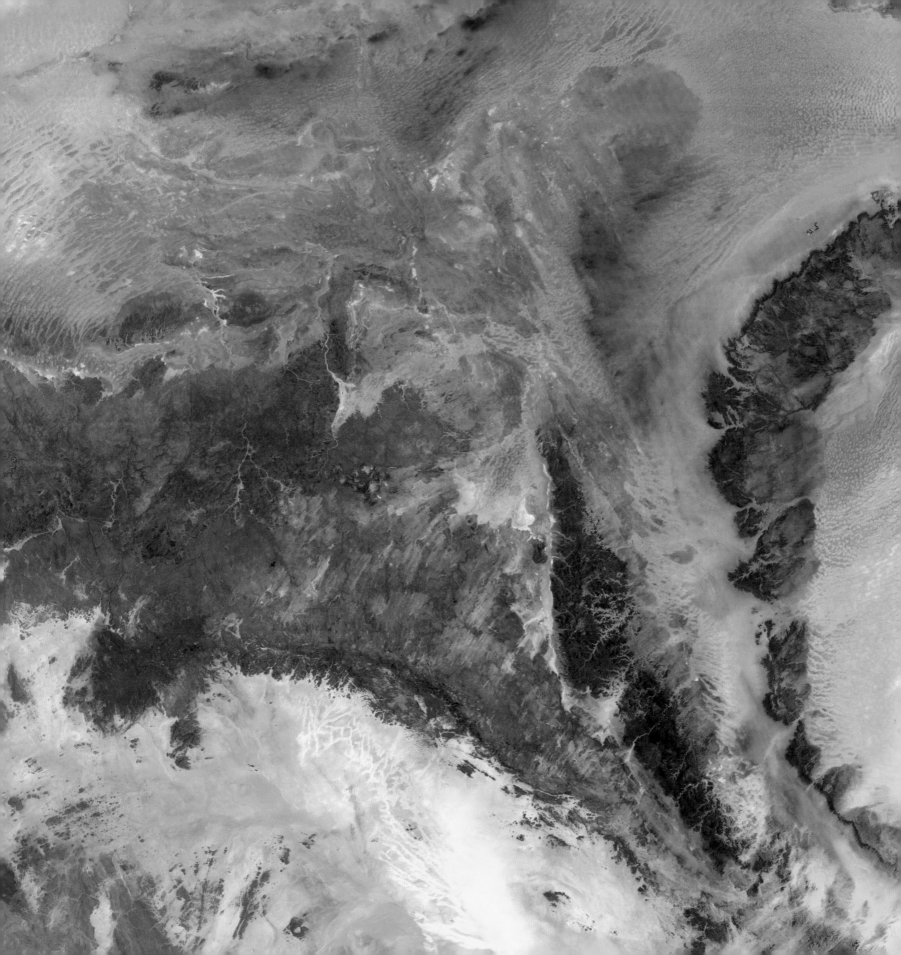

# Tibetan Plateau
# Central Asia

Central Asia's Tibetan Plateau is justifiably nicknamed the "Roof of the World," with an average elevation of more than 4,500 meters. It is the world's highest and largest plateau, covering an area roughly four times the size of France. The plateau includes the two highest mountains in the world (Mount Everest and K2) and the largest canyon in the world (Yalung Tsangpu River Great Canyon). The plateau was formed by the collision of the Eurasian continent and the India subcontinent, which still press against each other today. This 2005 Landsat 5 scene features some of the area's deep, glacier-fed lakes—the two largest in the image are Migriggyangzham near the upper left and Dorsoidong just below it.

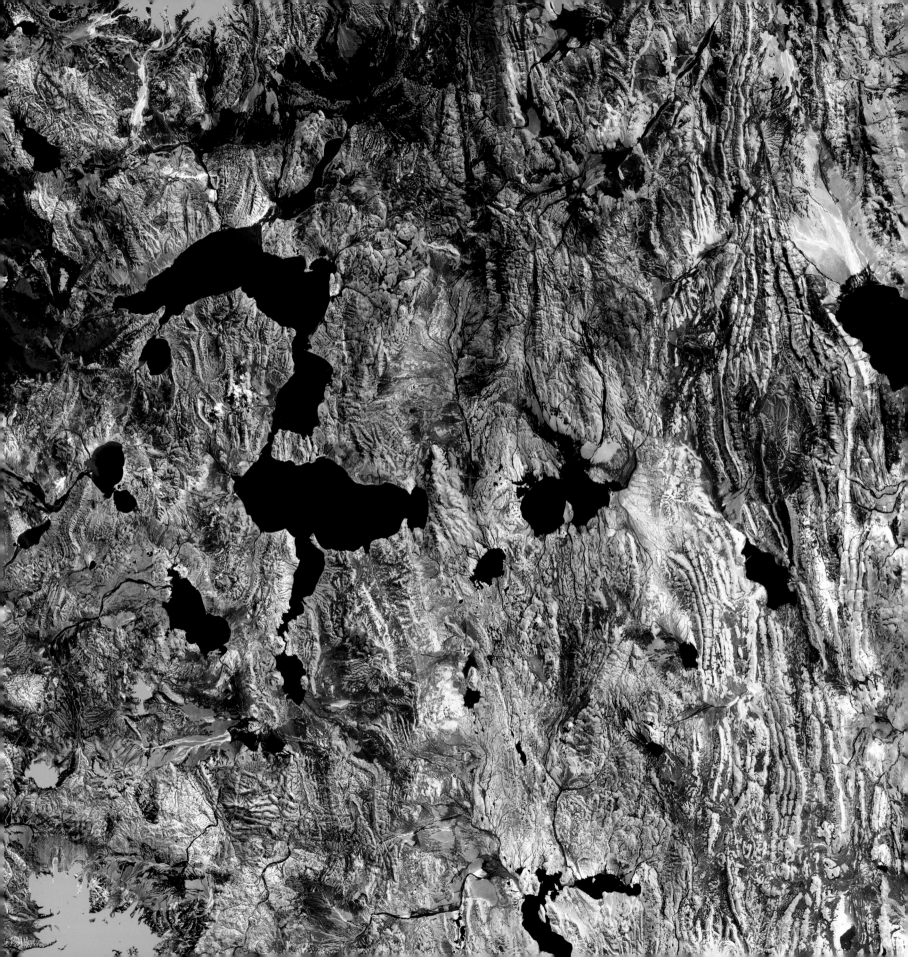

## Tikehau Atoll
## French Polynesia

A narrow ribbon of islets encircles a deep blue lagoon in French Polynesia. Tikehau Atoll is one of 78 coral atolls that make up the Tuamotu Archipelago, the largest chain of atolls in the world. Created over thousands of years by tiny, sea anemone–like coral polyps, atolls are some of the most complex and vibrant structures on the planet. In this 2009 EO-1 satellite image of the atoll, patches of coral make starlike spots across the turquoise expanse of the oval lagoon, 27 kilometers long and 19 kilometers wide. At the southernmost tip of the atoll, a large islet accommodates the village of Tuherahera and an airstrip. The whole atoll is surrounded by an almost continuous coral reef. There is a single pass on the western shore deep and wide enough for navigation in and out of the lagoon.

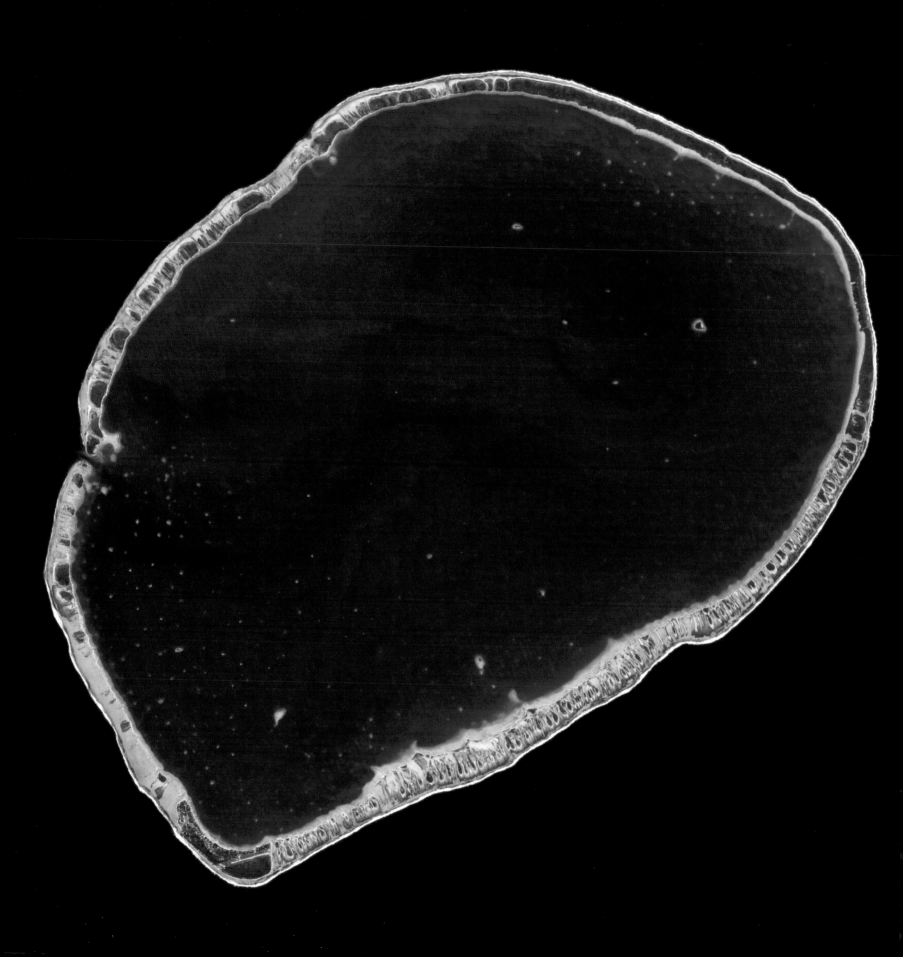

# Triple Junction
# East Africa

In the Afar region of Ethiopia, a nearly barren rockscape marks the location of the meeting place of three separate pieces of Earth's crust known to geologists as the Afar Triple Junction. Here, the spreading ridges that form the Red Sea and the Gulf of Aden emerge on land and meet the East African Rift. The central meeting place for these pieces is around Lake Abbe, just to the south of the area shown in this 2005 Terra image.

The three pieces are each pulling away from that central point, though not all at the same speed. The separation creates enormous stress on the rock, producing cracks, faults, volcanoes, fumaroles (gas vents), escarpments, and hot springs in the region along the border of Ethiopia, Eritrea, and Djibouti. One of Earth's few lava lakes, Erta Ale, is found in this area. In the image, the gray-brown, ancient, basalt rock of the region is crisscrossed by cracks both small and large, many of which are filled with salt and sand. The tinge of red indicates some hardy vegetation eking out a living in the harsh terrain. The large riverlike feature running horizontally across the scene is a geologic feature called a graben, a gulley created not by the erosion of a river but by the sinking of the ground where earth on either side pulls apart.

The Afar region is well known as one of the cradles of hominids. The region contains the Middle Awash, the site of many fossil hominid discoveries; Gona, the site of the world's oldest stone tools; and Hadar, the site of a fossilized specimen of *Australopithecus afarensis* known as Lucy.

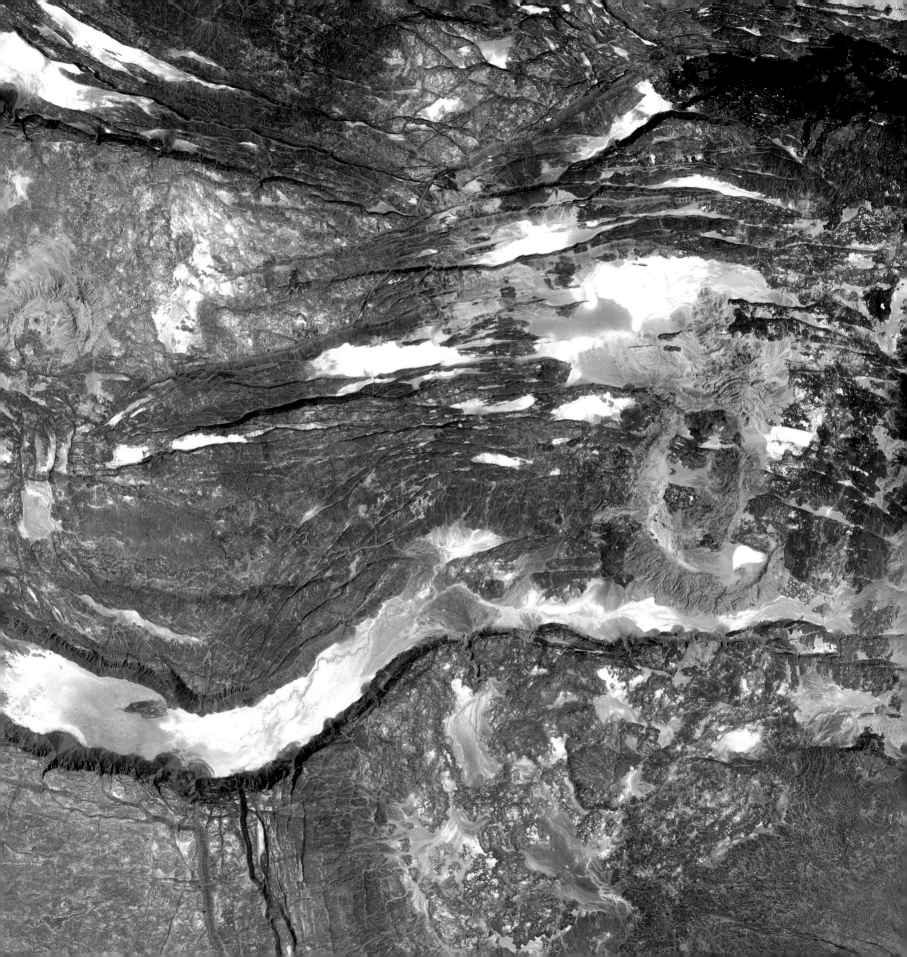

# Ugab River
# Namibia

Elusive and ecologically vital, Namibia's Ugab River only flows above ground for a few days each year. The subterranean waters underlying this ephemeral river, however, are shallow enough in places to fill hollows and sustain a wildlife population that includes black rhinos and rare desert elephants. In this 2002 Landsat 7 image, the river passes through nearly vertical layers of thinly bedded limestone, sandstone, and siltstone. One of Namibia's major rivers, the Ugab stretches nearly 500 kilometers from the interior to the coast of the Atlantic.

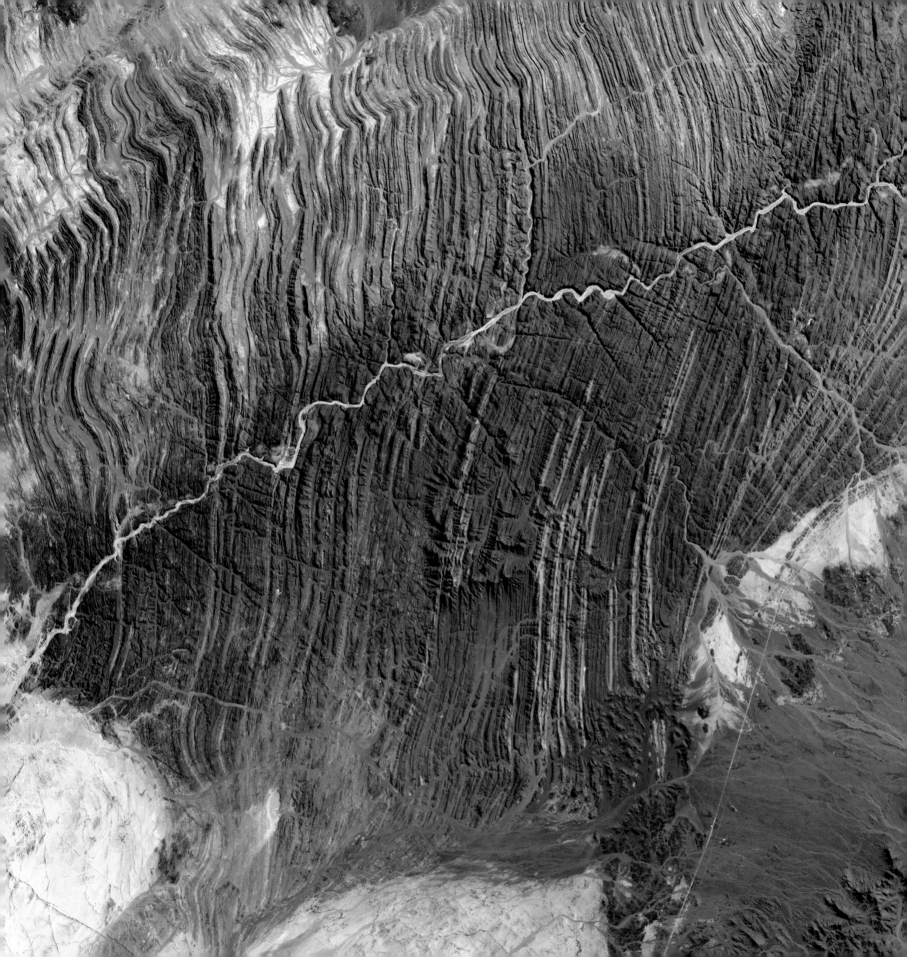

# Vatnajökull Glacier Ice Cap
# Iceland

Valley glaciers reach into lower lying areas from the Vatnajökull Glacier in Iceland's Skaftafell National Park. The largest ice cap by volume in Europe, Vatnajökull covers more than 8 percent of the island. Seven volcanoes and an ice cavern system are situated beneath the Vatnajökull ice cap. Iceland's highest peak, Hvannadalshnúkur, is located in the southern periphery of Vatnajökull. This 1999 Landsat 7 image shows the southeast portion of the glacier.

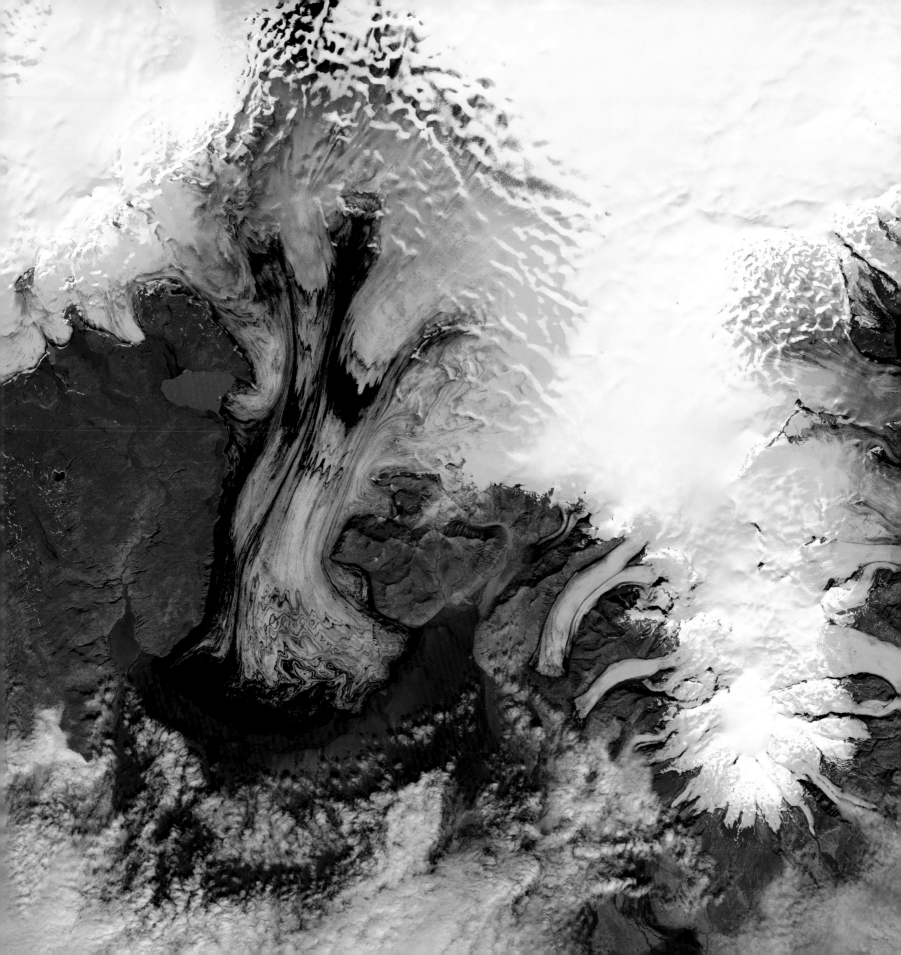

# Volcanoes
# Chile and Argentina

On the border between Chile and the Catamarca Province of Argentina lies a vast field of currently dormant volcanoes. Over time, these volcanoes have laid down a crust of magma roughly 3.5 kilometers thick. The intense blue features in this 1999 Landsat 7 image are playa lakes and ponds and surrounding salt deposits. The deeper lakes appear darker. Shallower areas in the lakes and moist salt deposits are lighter blue. Dry, salt-encrusted sediments adjacent to the lakes and ponds appear white. Chile has 36 historically active volcanoes, more than any other South American country.

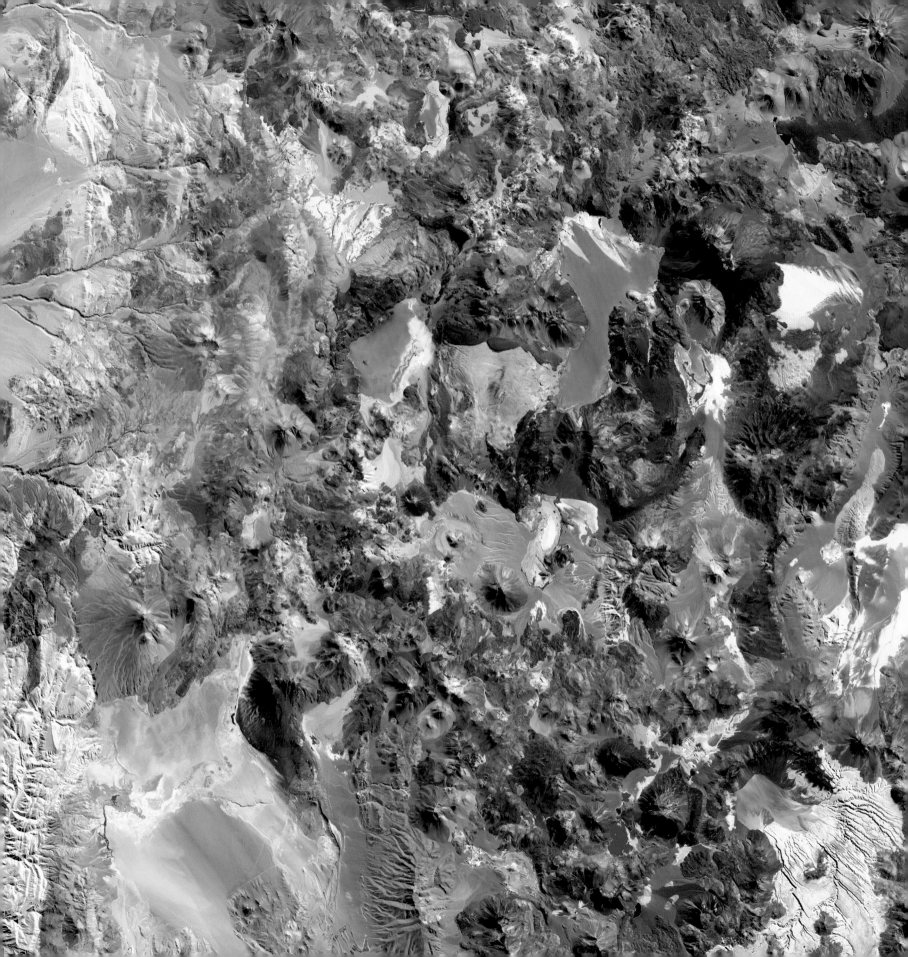

# Von Kármán Vortices
# Southern Pacific Ocean

Swirling clouds line up in a formation known as a von Kármán street. This phenomenon is named after aerodynamicist Theodore von Kármán, who derived the theoretical conditions under which it occurs (von Kármán was one of the principal founders of NASA's Jet Propulsion Laboratory). He described the alternating double row of vortices as "staggered like lampposts along both sides of a street." These vortices appear when wind-driven clouds encounter an obstacle, in this instance Alexander Selkirk Island in the southern Pacific Ocean. As the clouds flow around the rugged island, whose highest point reaches nearly 1.5 kilometers above sea level, the clouds form the spinning eddies visible in this 1999 Landsat 7 image.

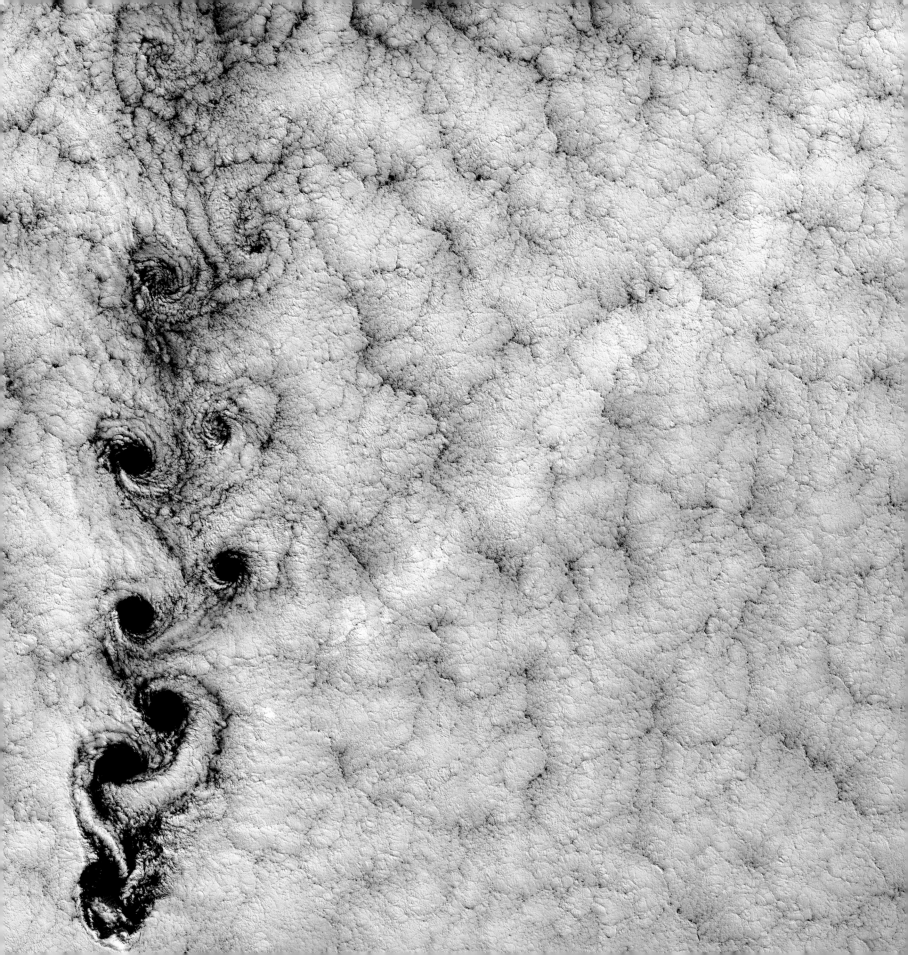

# Wadi Branches
# Jordan

The Terra satellite captured this image of wadis in southeastern Jordan in 2001. The Arabic word *wadi* means a gulley or riverbed that is usually dry except after drenching, seasonal rains. In this image, meandering wadis have combined to form dense, branching networks across the stark, arid landscape.

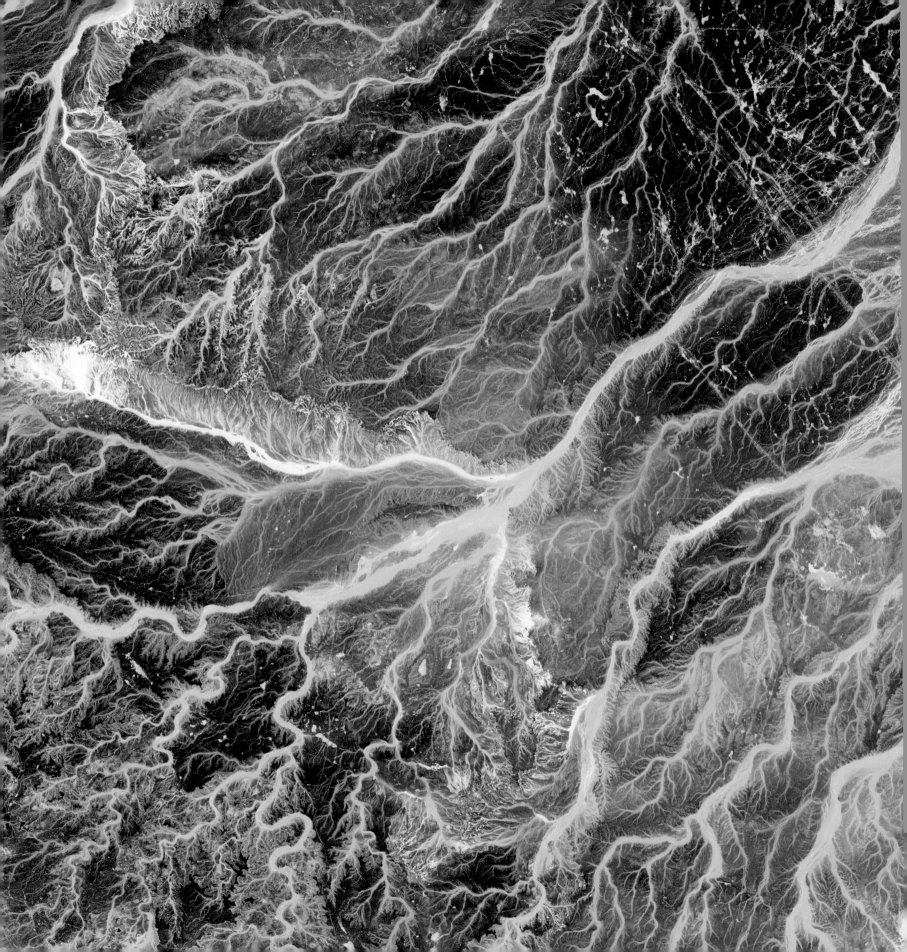

## Zagros Mountains
## Iran

The Zagros Mountains in southwestern Iran present an impressive landscape of long, linear ridges and valleys. In the lower right corner of this 2000 Landsat 7 image stands a feature of the area—a white-topped salt dome called Kuh-e-Namak, or "mountain of salt" in Farsi. Thick layers of minerals, such as halite (common table salt), typically accumulate in closed basins during alternating wet and dry climatic conditions. Over time, the layers of salt are buried under younger layers of rock. The pressure from overlying rock layers causes the lower-density salt to flow upwards, bending the rock layers above and creating a domelike structure. Near the bottom of the image, the Mand River resembles a lavender ribbon as it winds around the base of Kuh-e-Namak. The city of Konari and several other towns and small villages nestle nearby on the valley floor.

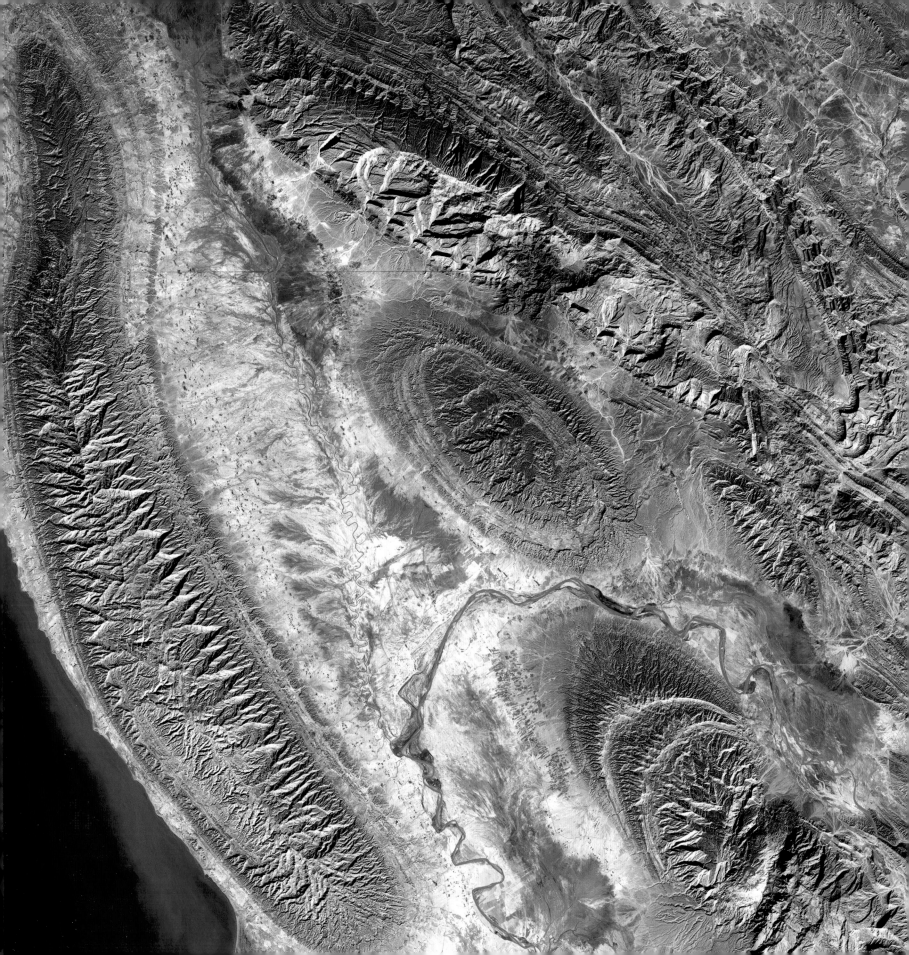

## About the Book

The United States has dozens of Earth-observing environmental satellites for scientific research and applied, operational purposes. This book features images from the Terra, Landsat 5, Landsat 7, Earth Observing-1 (EO-1), and Aqua satellites. The satellites' sensors can measure light outside of the visible range, so the images in the book are not necessarily ones visible to the naked eye.

NASA manages the Terra, Aqua, and EO-1 satellites. NASA and the U.S. Geological Survey jointly manage Landsat. Both agencies generated images used in this collection, and some involved cooperation with international partners. The images are intended for viewing enjoyment rather than scientific interpretation. More images and information are available at:
*http://eros.usgs.gov/imagegallery/*
*http://earthobservatory.nasa.gov/*

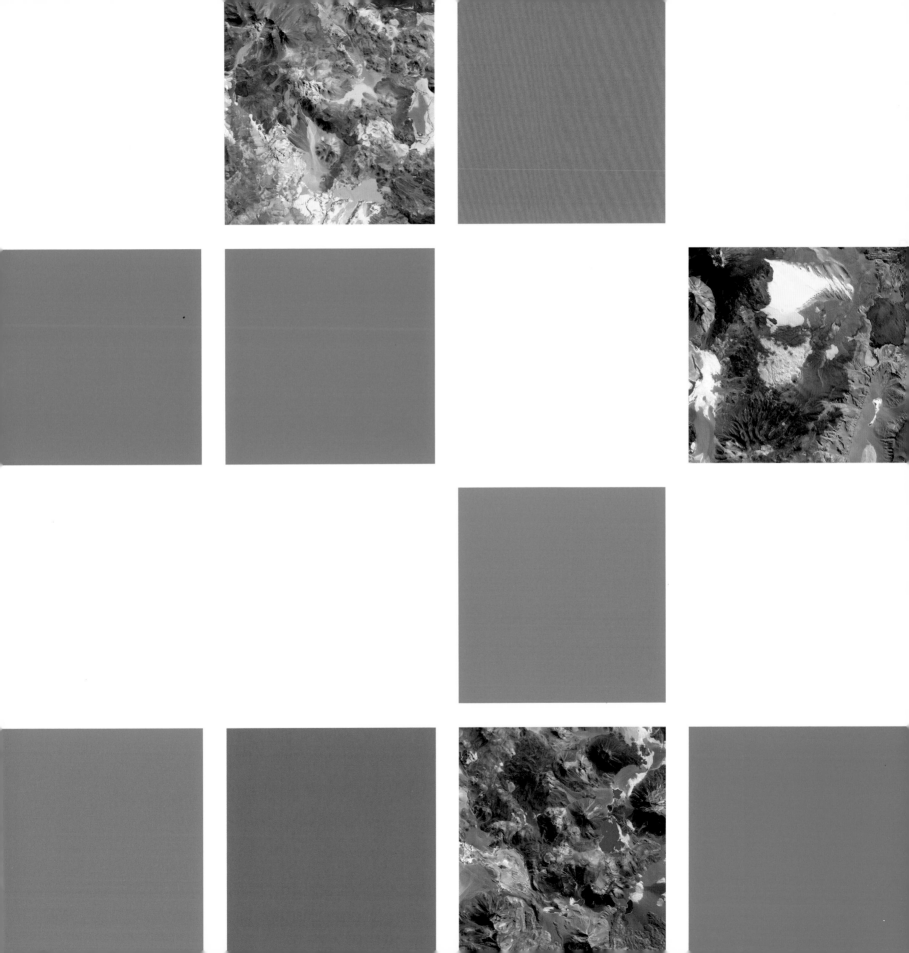

# Appendix

### Africa

| 6 | Algerian Desert, Algeria | Landsat 5 | 2009 |
|---|---|---|---|
| 10 | Anti-Atlas Mountains, Morocco | Landsat 7 | 2001 |
| 18 | Bombetoka Bay, Madagascar | Terra | 2000 |
| 20 | Brandberg Massif, Namibia | Landsat 7 | 2002 |
| 36 | East African Rift, Kenya | Terra | 2002 |
| 40 | Erg Chech, Algeria | Landsat 7 | 2003 |
| 42 | Erg Iguidi, Algeria and Mauritania | Landsat 5 | 1985 |
| 44 | Erongo Massif, Namibia | Landsat 7 | 2003 |
| 60 | Jebel Uweinat, Egypt | Terra | 2002 |
| 62 | Kalahari Desert, Southern Africa | Landsat 7 | 2000 |
| 66 | Kilimanjaro, Kenya and Tanzania | Landsat 7 | 2000 |
| 86 | Mount Elgon, Kenya and Uganda | Landsat 5 | 1984 |
| 90 | Namib Desert, Namibia | Landsat 7 | 2000 |
| 94 | Niger River, Mali | Terra | 2003 |
| 96 | Okavango Delta, Botswana | Landsat 5 | 2009 |
| 108 | Richat Structure, Mauritania | Landsat 7 | 2001 |
| 122 | Southern Sahara Desert, Africa | Landsat 5 | 2009 |
| 128 | Tassili n'Ajjer, Algeria | Landsat 7 | 2000 |
| 130 | Terkezi Oasis, Chad | Landsat 7 | 2000 |
| 132 | Three Massifs, Sahara Desert | Terra | 2000 |
| 138 | Triple Junction, East Africa | Terra | 2005 |
| 140 | Ugab River, Namibia | Landsat 7 | 2002 |

## Central and East Asia

| | | | |
|---|---|---|---|
| 8 | Alluvial Fan, China | Terra | 2002 |
| 12 | Anyuyskiy Volcano, Russia | Landsat 7 | 2001 |
| 16 | Bogda Mountains, China | Landsat 7 | 1999 |
| 30 | Dardzha Peninsula, Turkmenistan | Landsat 7 | 2001 |
| 32 | Dasht-e Kavir, Iran | Landsat 7 | 2000 |
| 38 | Edrengiyn Nuruu, Mongolia | Landsat 7 | 1999 |
| 52 | Great Salt Desert, Iran | Landsat 7 | 2003 |
| 54 | Himalayas, Central Asia | Terra | 2001 |
| 64 | Kamchatka Peninsula, Russia | Terra | 2002 |
| 76 | Lena River Delta, Russia | Landsat 7 | 2000 |
| 80 | Mayn River, Russia | Landsat 7 | 2000 |
| 106 | Ribbon Lakes, Russia | Landsat 5 | 2005 |
| 134 | Tibetan Plateau, Central Asia | Landsat 5 | 2005 |
| 150 | Zagros Mountains, Iran | Landsat 7 | 2000 |

## Europe and West Asia

| | | | |
|---|---|---|---|
| 88 | Musandam Peninsula, Oman | Terra | 2004 |
| 102 | Phytoplankton Bloom, Baltic Sea | Landsat 7 | 2005 |
| 112 | Rub' al Khali, Arabian Peninsula | Landsat 7 | 2001 |
| 126 | Syrian Desert, West Asia | Landsat 7 | 2000 |
| 142 | Vatnajökull Glacier Ice Cap, Iceland | Landsat 7 | 1999 |
| 148 | Wadi Branches, Jordan | Terra | 2001 |

## North America

| | | | |
|---|---|---|---|
| 2 | Akpatok Island, Canada | Landsat 7 | 2001 |
| 14 | Belcher Islands, Canada | Landsat 7 | 2000 |
| 34 | Desolation Canyon, United States | Landsat 7 | 2000 |
| 46 | Garden City, United States | Landsat 7 | 2000 |
| 58 | Isla Espíritu Santo and Isla Partida, Mexico | Terra | 2002 |
| 82 | Meandering Mississippi, United States | Landsat 7 | 2003 |
| 84 | Mississippi River Delta, United States | Terra | 2001 |
| 98 | Painted Desert, United States | Landsat 5 | 2009 |
| 104 | Pinacate Volcano Field, Mexico | Landsat 7 | 2002 |
| 110 | Rocky Mountain Trench, Canada | Landsat 5 | 2004 |
| 114 | Sand Hills, United States | Terra | 2001 |
| 118 | Sierra Madre Oriental, Mexico | Landsat 7 | 1999 |
| 124 | Susitna Glacier, United States | Terra | 2009 |

## Oceania

| | | | |
|---|---|---|---|
| 24 | Cape Farewell, New Zealand | Terra | 2001 |
| 28 | Carnegie Lake, Australia | Landsat 7 | 1999 |
| 72 | Lake Disappointment, Australia | Terra | 2000 |
| 74 | Lake Eyre, Australia | Landsat 5 | 2006 |
| 78 | MacDonnell Ranges, Australia | Landsat 7 | 2000 |
| 116 | Shoemaker Crater, Australia | Landsat 7 | 2000 |
| 136 | Tikehau Atoll, French Polynesia | EO-1 | 2009 |

## Oceans, Atmosphere, and Polar Regions

| 4 | Aleutian Clouds, Bering Sea | Landsat 7 | 2000 |
| 22 | Byrd Glacier, Antarctica | Landsat 7 | 2000 |
| 26 | Carbonate Sand Dunes, Atlantic Ocean | Terra | 2002 |
| 48 | Grand Bahama Bank, Atlantic Ocean | Aqua | 2009 |
| 50 | Gravity Waves, Above the Indian Ocean | Terra | 2003 |
| 56 | Ice Waves, Greenland | Landsat 7 | 2001 |
| 68 | Kuril Islands, Sea of Okhotsk | Landsat 7 | 2000 |
| 120 | South Georgia Island, South Atlantic Ocean | Terra | 2002 |
| 146 | Von Kármán Vortices, Southern Pacific Ocean | Landsat 7 | 1999 |

## South America

| 70 | La Rioja, Argentina | Landsat 5 | 1985 |
| 92 | Nazca Lines, Peru | Terra | 2000 |
| 100 | Paraná River Delta, Argentina | Landsat 7 | 2000 |
| 144 | Volcanoes, Chile and Argentina | Landsat 7 | 1999 |

## Acknowledgments

NASA acknowledges those who worked to produce these wonderful images. All of the people in the public and private sectors who designed the remarkable sensors, operated the robust satellites, and processed the stunning images deserve special recognition and praise.

Several individuals supported the development of the book and the selection of images, particularly Karen Yuen, Rosemary Sullivant, Kathy Carroll, Stephen Schaeberle, George Gonzalez, Lisa Jirousek, Tun Hla, Jennifer Friedl, and Andrew Noh.

EARTH AS ART